Founder/Editor-in-Chief: Kate E. Hinshaw
Editors: Andi Avery, Hogan Seidel, Gabby Sumney
Cover Design: Jay Capriglione
Analog Cookbook Logo: Sarah Lawrence's Design Emporium
Questions: hello@analogcookbook.com
Published by Analog Cookbook © 2022

The Allure: or how I shot my directorial debut on 16mm film + some tips for those looking to direct a narrative work on analog Pg 6
Essay by Joanna Decc

we breathe each other in and out of existence Pg 10
An installation incorporating handmade, botanical 16mm strips and digitized projections by Archer Boyette

Big Agnes Ascent Pg 16
a pinhole 16mm film created on a single roll with a hand-cranking camera in the mountains of Colorado by Kevin Obsatz

Letter from Korlai Pg 20
A Short Essay Film on 16mm Film by Aman Wadhan

Trengellick Rising: Pg 26
A Cornish language short film and deep dive into a cinematic rabbit hole. Essay by Guy Potter

Building an Edge Pg 36
35mm moving image made with a LomoKino camera by Britany Gunderson

Cyanotype Madness: A Timeline Pg 40
Essay and recipe by Gabby Sumney

The Garden of Edén: Solar Equator + Iceland: Land of Fire and Ice Pg 48
Anthotype series by Alejandra Orjuela

The Perfect Human Pg 52
16mm Experimental Film by Lilan Yang

King Presley Pg 56
A short magical realism documentary by Giovanni Tortorici

The Samsara I Saw Pg 60
Experimental Film by Gabriel D. Evaristo

Once + that I have broken into two Pg 64
Essay and film by Ellery Bryan

Sun Coming and Casting a Shadow Pg 72
Super 8mm film by Daniel Robin

This Little Light Of Mine: Why is Experimental Cinema the best way to talk about epilepsy? Pg 78
Essay by Malo Sutra Fish

Movement and Potential in analog futures Pg 84
Essay and Recipe by Ciccio Coppola

Music Film and Series of darkroom lightgraphic prints Pg 90
by Elvira Akzigitova

My Selves Dissolving + Weekend Control By N~KURFEW Pg 96
Experimental Film and Music Film by Danielle Wakin

Rainbow Tunnel Films Pg 100
Artist-run full service creative studio by Claire Donohue and Sarah Phenix

The Allure

or how I shot my directorial debut on 16mm film + some tips for those looking to direct a narrative work on analog.

-Joanna Decc

I knew from the early beginnings that I wanted Bleak as the Setting Sun to be shot on film. My directorial debut about the intricacies of caregiving; a passage through the ups and downs of caring for a loved one, and an exploration of the tangible tasks that come with such a role: the methodical administration of pills, the long hours of hand holding, and the moments of silence that exist in between.

The first allure to film was the grain, that illusion to former days, an inherent nostalgic quality that didn't feel like it worked quite as well when superimposed on a sleek digital image. I longed for this true-to-life texture that grain adds to every surface captured. Yet, it wasn't merely the grain or the captivating colors of film that I sought, but more so those hidden intrinsic qualities of the analog process itself.

A few months into pre-production I began a job at a motion picture lab, it was there that I realized that while not always, often times, film was a tactile medium that required a string of individual artists to leave their faint fingerprints on various stages of its movement. From the 2nd AC who would load the film, to the lab technician who would develop it, to the scanning technician prepping the film for its digitization, and finally, eventually, that same film that had passed through all these people, would eventually make it's way back to me. With community being so integral to the story behind the film and in the process of creating the film, this communal aspect of analog

especially, felt like magic. The idea of shooting a large scale project on film (having never directed before) felt out of reach, and yet with the correct brew of delusion and spunk I was determined to make it happen.

For almost a year before going into production I shot tons of film, beginning with makeshift operations in my bathtub involving double 8, instant coffee, washing soda, and vitamin C– to that inevitable super 8– to 16mm. Without realizing it, a year had gone by and I had fallen in love, and moreover, I was completely set on shooting film.

Tip 1: Shoot some film! (If you're not obsessed already). As a director you can definitely rely on your DP and camera team to do this work on set, but understanding the medium first hand will streamline conversations between you and the camera department, not to mention allow you to be well versed in the creative decisions surrounding the workflow around film. Apart from the invaluable knowledge you will gain from shooting yourself, you may even fall in love with the medium.

When funding for the film was finally in place, one of the first things I sought out to do was a stock test. Originally I thought for sure we'd shoot on 500T, it seemed like the safest, most versatile option. However after testing a few different options we settled on 250D, with a few cans of 500T for some night scenes. 250D as the main stock was definitely the right choice and helped land the film in the world I sought out to create.

Tip 2: Shoot a stock test. Try to get the camera or at least the lenses you plan on using. Combine the lens test with the stock test. If you can involve any of the following: access to the location you will be shooting at, production design (or at least your color palette) and mimic the lighting–you're golden.

As the shoot days drew closer and I was securing cans for the shoot I realized that while I had a vague idea of how many cans I'd need, I really wasn't sure, so I spent one (long) evening timing the script. This involved playing out the length of all the shots in my head, acting out the scenes with the pace I imagined, and then adding up the long list of numbers I had accumulated per shot.

Tip 3: Time the script. Timing the script will give you a good gauge of how many cans (or rolls) you will need for the whole film. Based on the final number you can do the math to cover your ideal amount of takes per shot.

I'm pleased to say (post-shoot) I wasn't too far off! Now we did shoot a few extra cans, which brings me to tip 4.

Tip 4: Buy a few extra cans. There is a good chance you may need them. If you don't use them you can always sell them online or to other film buffs (most places won't take film returns), keep them for your next project, or have a lab spool them down for you so you can shoot them in your Bolex etc.

With the film now shot, processed, and scanned–and the negatives safely back in my possession, I can say it was absolutely worth the ride.

I keep thinking back to how creating a film is such a collaborative process. Even during my year of shooting alone, I looked forward to going to my local lab to pick up stock, chatting with other artists, asking those more knowledgable than me about all my various perplexities surrounding film. It's never quite felt like it was only me involved. With *Bleak as the Setting Sun* more so than ever I felt the communal aspect of film. What started with a purely aesthetic allure has morphed into an allure for the analog film community, and how for some reason, we're all drawn and connected via this charming bygone format.

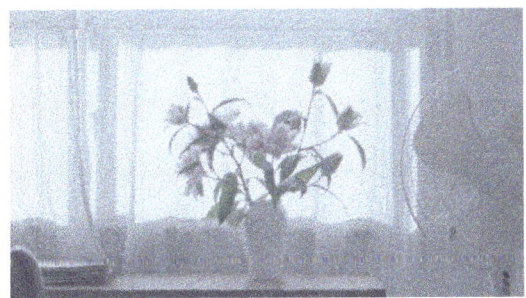

we breathe each other in and out of existence

An installation incorporating handmade, botanical 16mm strips and digitized projections

Archer Boyette

Tell us about your background as an artist.

I started making work in high school, primarily collaging and painting in a visual journal. I transitioned to photography in college, and after studying global cinema, decided to give filmmaking a go. Looking back, it makes sense that I ultimately stumbled into an analog-centric installation. My heart is with moving images, but as an artist, I prefer the experience of working with my hands.

You mention a sense of detachment in filmmaking and turning to tactile filmmaking. How did it feel to gather these plants and attach them to film one by one?

Yes, I think I (like many) struggle with the camera as an intermediary. I found this struggle more pronounced when filming plants, unable to relay all of their intricacies, quirks, and behaviors. The act of filming, even with the forced slowness of the Bolex, is not slow enough to match the language of plants. Tactile filmmaking, however, embraces that sort of slowness entirely. I spent days in the forest familiarizing myself with the plants, learning their names and their hiding spots, learning when to harvest and when to let something grow. More hours spent at home, carefully separating the plants, re-wetting those that had begun to dry, and placing individual leaflets, fronds, and stems onto each frame. Later, hours at the optical printer photographing frame-by-frame. The process felt simultaneously intimate and ritualistic; it fostered a deeper connection between myself and the plants, and enabled greater respect in the act of image-making.

This piece is part installation, part sculpture, part film. How did you make the decision to show this piece in multiple modes?

After working with the plants and the film strips for so long, it felt like they were just as beautiful as – if not more beautiful than – the final digitized films. It didn't make sense for them to exist separately because they were two parts of a whole. The plants living and dying on analog film in their natural microscopic form, side-by-side with digital, macro projections… it felt like the best way to see the plants for what they are: tiny, delicate, and precious, and simultaneously intricate, ornate, and grand. Other aspects of the installation were methods of establishing specificity of place, e.g. audio recordings of creeks and bird calls taken on my hikes, tree stumps for seating, and a meandering path to mimic walking through the forest. It's both a practical and emotional compass pointing to Western North Carolina as home, for the plants and myself.

What do you hope audiences learn about the Pisgah National Forest through *we breathe each other in and out of existence***?**

I would say my aspirations are less didactic and more emotional. When individuals spend time in the installation, I hope they can feel the same sense of calm and wonder I feel when I'm in Pisgah, and extrapolate that feeling to the natural environments that are most comforting and/or familiar to them.

Anything surprise you in the process of making this piece?

With the right attitude, you can convince a whole lot of people to move 8 extremely heavy tree stumps.

You have several interesting films that merge environment and medium so beautifully-including a film that recreates acid rain through creek water and bleach, and phytogram studies. What's been your favorite film to make so far?

I did enjoy getting weird looks at AutoZone when I went to buy battery acid for *Acid Rain*, which ultimately had no effect on the emulsion (the more you know – thanks, bleach). Truthfully, the films I make are mostly just excuses to get out of my house and explore the woods, and for that reason I don't have a favorite. At least, not yet.

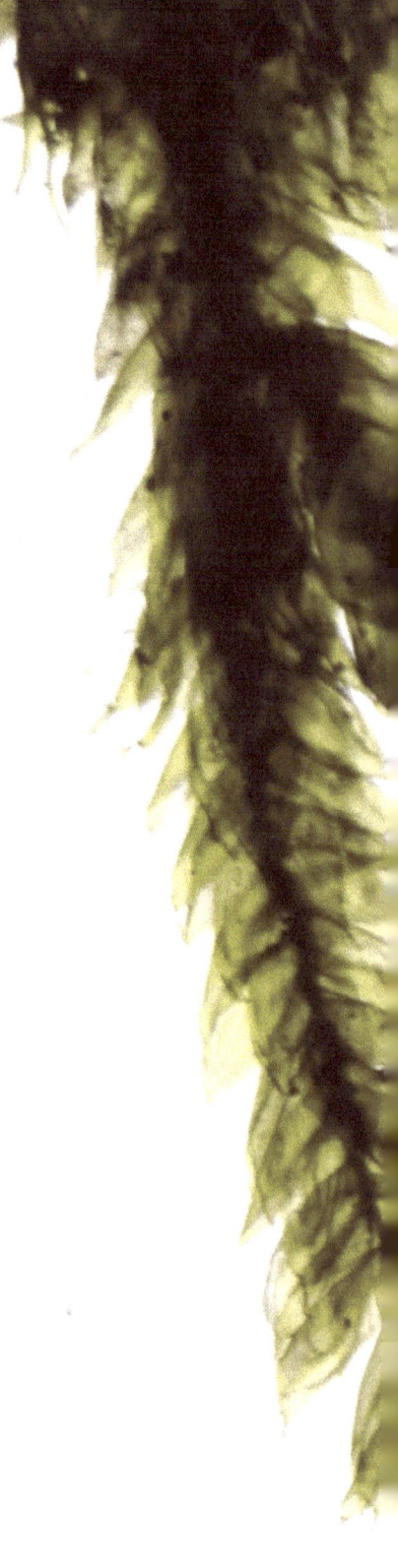

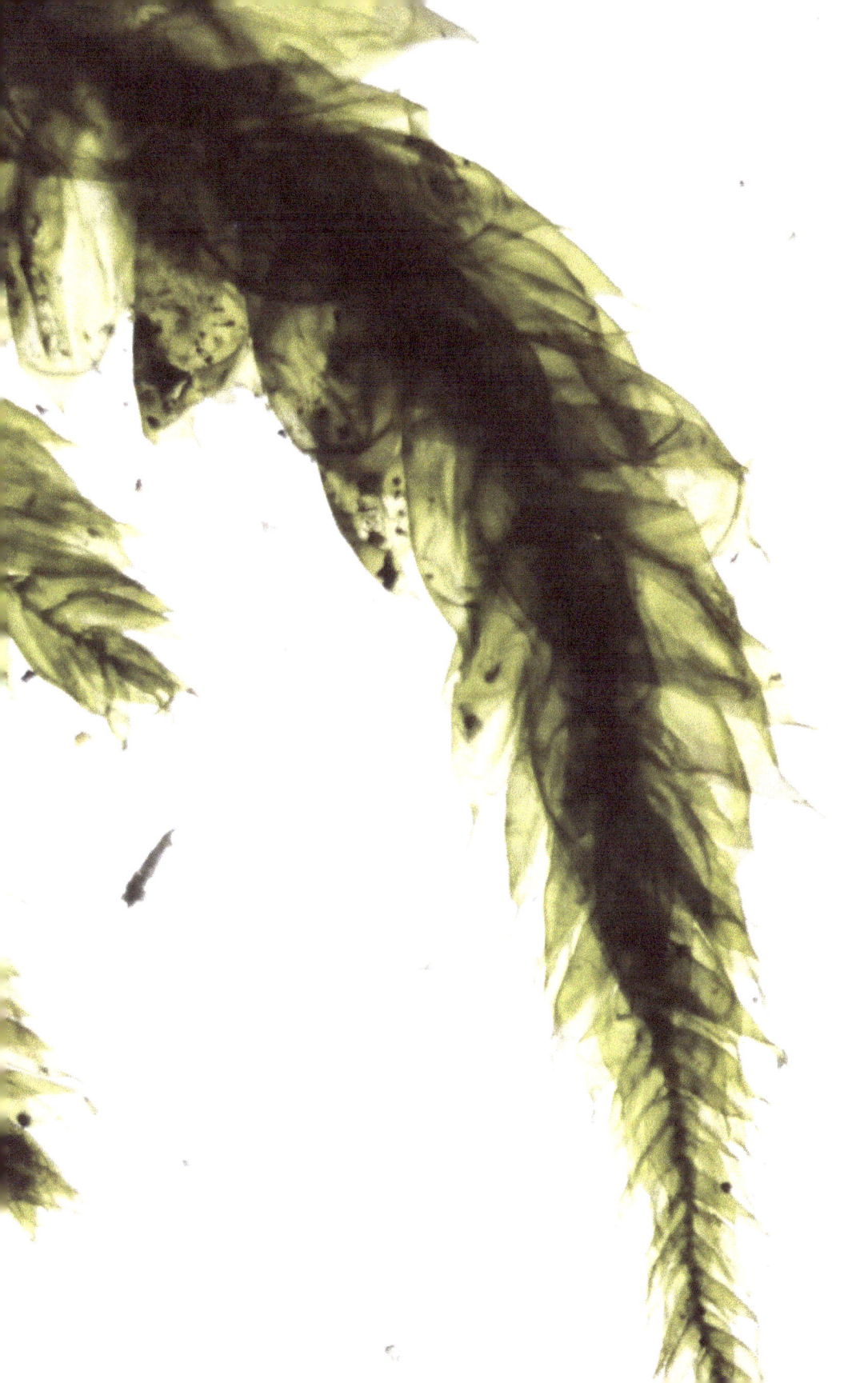

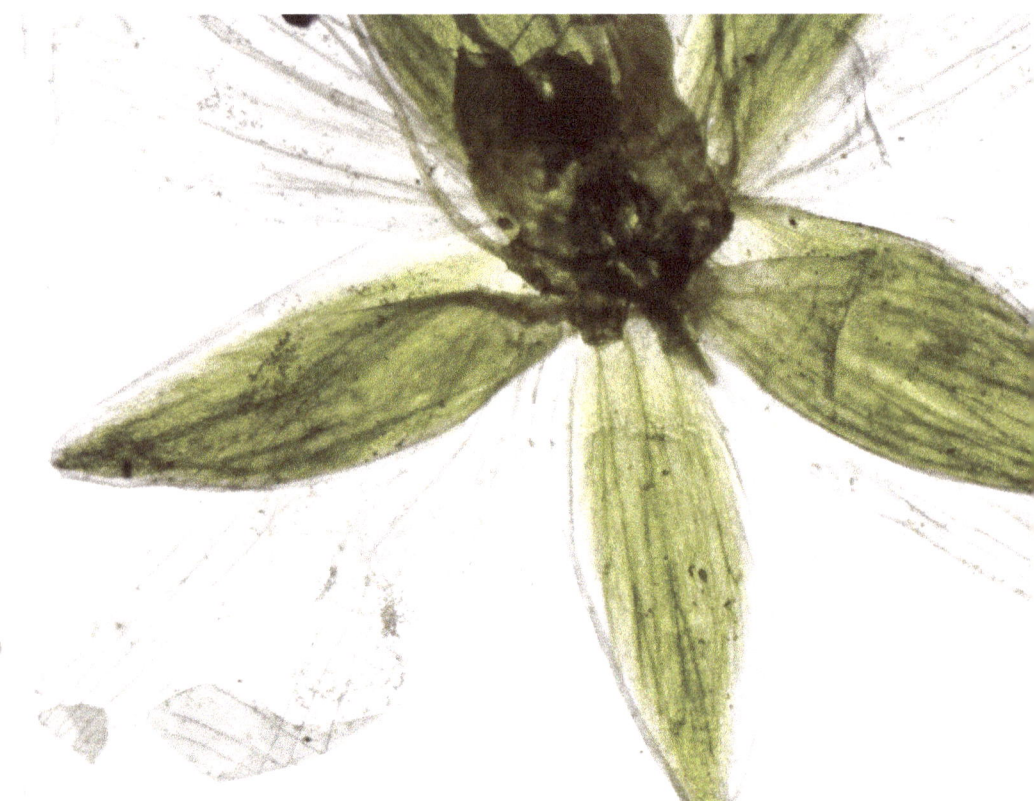

Tell us about your upcoming film *Cold Moon Communion*!

Sure! *Cold Moon Communion* is a three channel film that melds recognizable spiritual imagery with various scenes of the forest surrounding my childhood home, shot in black and white 16mm back in December 2020 on the day of the cold moon. The film explores the sacred ties that bind land, animal, human, and plant.

Grappling with the environment as an analog filmmaker is a common theme we see in works submitted to Analog Cookbook. What do you hope audiences can learn from environment filmmaking?

I'm struck by the capacity for analog to enable artistic collaboration with the environment, e.g. lending the environment agency in the image-making process. Our current ecological predicaments stem from a history of conquest and exploitation. It's our responsibility as artists to interrogate the ways in which our individual practices uphold, upend, or subvert this history. For me, rejecting rapid processes and ends-oriented creating is a way to realign myself with the slow, steady, and deliberate processes of the natural world.

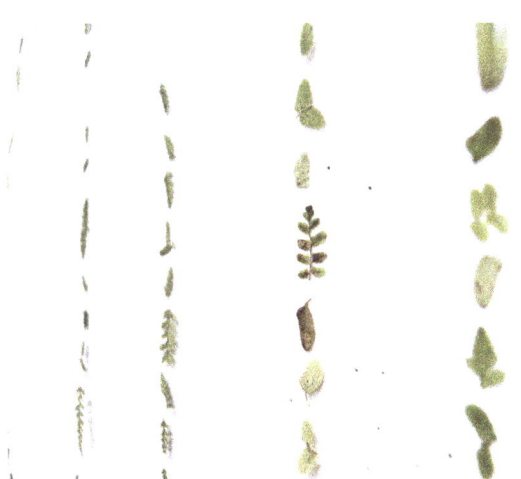

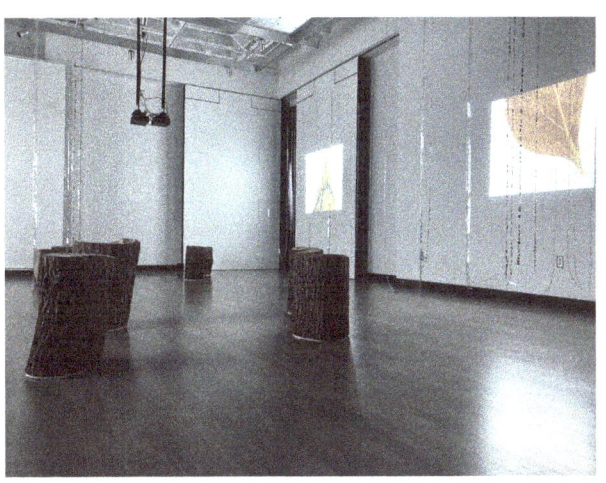

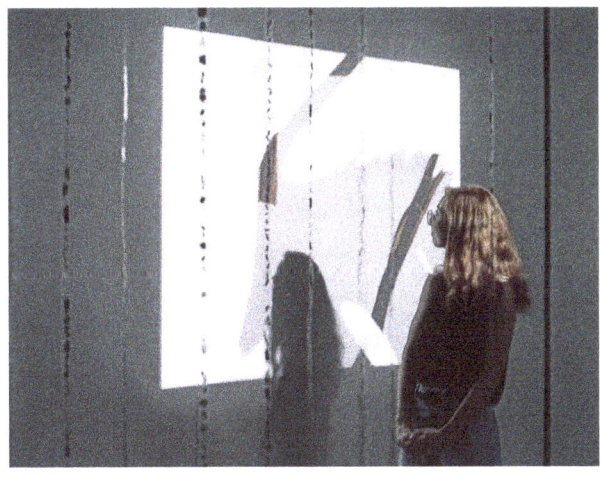

Big Agnes Ascent
Kevin Obsatz

Big Agnes Ascent - a pinhole 16mm film created on a single roll with a hand-cranking camera in the mountains of Colorado.

There is no viewfinder, shutter mechanism, frame registration, spring or motor. The camera is designed to work with title stock, extremely slow film, and what I found in the direct mountain sunlight was that one second per exposure was about right. So every shot in Big Agnes Ascent represents several minutes of me standing very still, timing each frame to about one breath, and carefully advancing the crank what felt like one frame.

It was important to me to leave those shots "whole" in the film, so there was basically no editing besides slowing down the footage to 50%, and cutting out a few shots that didn't work for one reason or another. It's also all presented chronologically, from the beginning of the ascent to the peak of the mountain.

All in all, it was probably the most singular filmmaking experience of my life. Everything kind of stripped away, leaving just me, the mountain, this simple camera, and a single roll of very slow film.

Big Agnes Ascent has such unique visuals! How did you create the overall look of the piece?

The camera itself was created by Robert Schaller of the Handmade Film Institute. It is this wonderfully awkward little constraint machine, fashioned out of two plastic daylight reel boxes, gaff tape, and a simple cranking mechanism. I know that Robert is well known in the analog community, so I keep expecting to see more films made this way out in the world, but I don't think I've ever seen another one, besides Robert's own work.

What inspired you to work with pinhole photography on 16mm film?

I don't remember where I heard about the Handmade Film Institute, but at that time I had been earning a living shooting and editing video for a number of years. I remember trying to pursue creative projects with my video camera, which was either a Sony PD-170 or a Canon XH-A1 at that point. And even though I liked freelancing for a living, one of the unfortunate side effects was that doing anything with my video camera started to feel like a job, like someone should be paying me and telling

me what they wanted. I couldn't separate the object (camera) from the role (freelancer).

What I needed was a completely different set of tools for being an artist, and the Handmade Film Institute, and the pinhole camera, was my first step in figuring that out. There was so much chance and serendipity involved in getting any kind of usable image back from that process, it was (I felt) impossible to commercialize. Which made it safe, for me, as an art process.

Tell us about this wilderness filmmaking expedition you went on to make this film.

I idealize it in retrospect, but at the time it was a tremendous mental and physical challenge for me. We hiked up into the mountains in Colorado, and our base camp was at (I think) about 10,000 feet. I just looked it up, and the peak of Big Agnes is about 12,000 feet. I'm from Minnesota, and I wasn't in great shape to begin with, so the hike itself, with a 30+ pound pack, was really hard, for the first few days especially.

The trip was timed with the New Moon, so we could develop our footage in the open air at night Robert had figured out that starlight wouldn't expose the slow title stock film. So we processed the footage by heating up the darkroom chemistry over an open fire in the middle of the night. Which was, on one hand, very romantic - but it was also frigidly cold, and very very late, since it was close to summer solstice.
There was also no cell phone reception up there, which was profound in its own way - I went eight full days without hearing the news, without any contact with the outside world. I don't think I've had as long or thorough a digital detox since then.

This film is from 8 years ago. What do you think would change if you made this piece today?

Maybe it sounds pretentious, but this is one of those rare projects where so many things that were beyond my control went miraculously right, I kind of don't feel like it was me making it. It was one of those very singular one-with-the-universe art-making moments, the kind that I hope to experience once a decade or so. It's funny, though it's an older piece, I have been continually pleased by the positive response to it. It feels kind of timeless.

I brought out the pinhole camera again for my MFA thesis, and made these hour-long tracking shots with it in China, which became part of a four-screen installation. I love that piece too, but it's a little harder to share online.

I feel like I'll revisit this camera and this process again in the future, but it requires a really monumental, sunlit and slow-moving subject matter - partly because the lens is so wide - and I haven't figured out what else needs to be filmed with it, yet.

How did you create the soundscape for this piece?

I'm fortunate to know, in the community of artists in Minneapolis, some very analog and film-oriented musicians, who perform live scores for silent features on a regular basis. The soundscape process for this film was as simple as asking one musician/composer,

Eric Struve, and he came back with something that felt perfect. There were no edits or revisions.

Do you have a favorite go-to filmmaking tool?

The pinhole camera kind of fell into my lap (thanks to Robert Schaller), and then my next camera, an older, parallax Bolex, was kind of loaned/gifted to me for the better part of a decade, before the guy wanted it back. I have a number of digital cameras, but none of them has that talismanic vibe to it, so I guess I'm currently kind of waiting to see what will present itself to me next.

What's next for you?

The last few years I've been moving back in a narrative direction, though I'm still trying to avoid dialogue as much as possible. Working with 16mm led me to begin programming experimental film screenings for Cellular Cinema in Minneapolis, and teaching, and I just finally landed a tenure-track job at the University of Wisconsin, Stevens Point. UWSP doesn't have any analog moving image course offerings… yet. But we'll see what's possible here over the next few years.

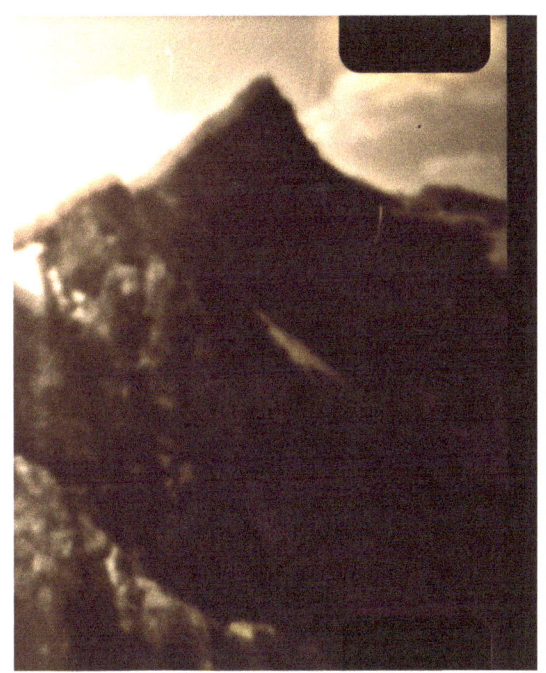

Letter from Korlai

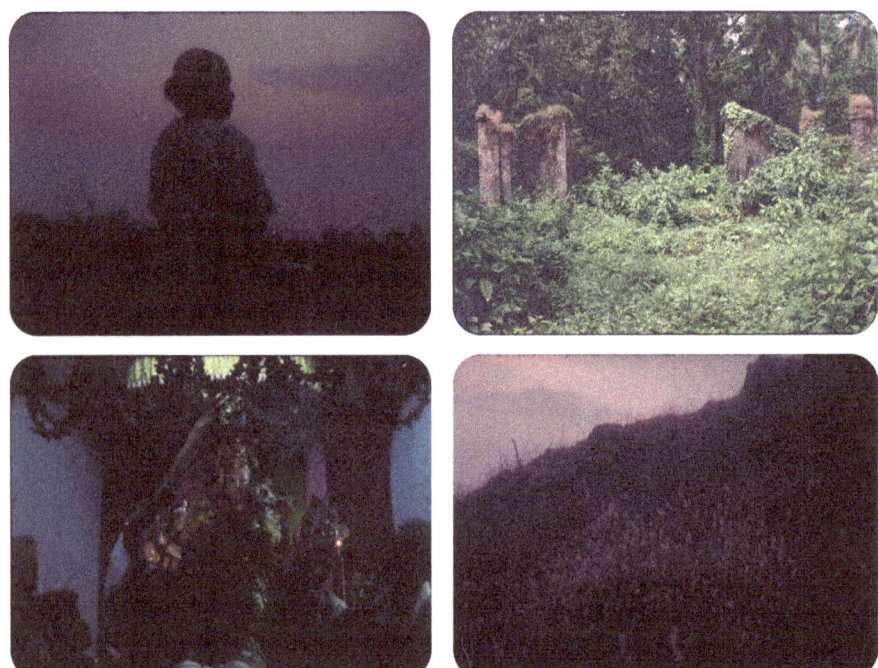

Short essay film by Aman Wadhan

Tell us about your background as a filmmaker.

Let me begin with the conjunction of two fortuitous events in my life. One, the arrival of broadband internet in my hometown, Chandigarh, just when I was embarking on a journey of self-learning as a cinephile and pirate-librarian of cultural artifacts; and two, meditation, for ripening my heart to receiving and bearing witness. I was already into my 27th year when I left IT and network security work to join the direction program at the Film and Television Institute of India, Pune. FTII's verdant residential campus was like an orphanage for curious wanderers; there I got the chance to learn on celluloid, make a few offbeat shorts, curate daily film screenings for fellow students, and have the privilege of choosing from an impressive collection of film prints belonging to the National Film Archive of India, situated just across the road. I also traveled as much as I could, especially in southern India, drawn to nature, tradition and things soulful. Filming, at the best of times, as an illimitable alchemical avocation, can be more than an intercession between the physical and the phenomenological. Attending film projections and shooting on film have helped me cultivate a sensorial and distinctly haptic approach to imaging that complements the devotional core of my film praxis. Letter from Korlai, my diploma film from FTII, embodies these aspects.

This film is such a beautiful meditation on Korlai. What do you hope audiences walk away feeling or know about Korlai after they watch this piece?

Shānti. A serene repose after having expended one's full attention. The "deep silence" that some viewers have reportedly partaken at the end of a screening may be consequential to their own attentiveness and openness to the film's quiet transcendental ardor. I believe it's a work that rewards multiple viewings. It's nice if it makes anyone in the audience curious about Korlai, though I'd be happier if they accept the film's invitation and wander off to a place of their own calling, one that they have loved or have been haunted by, and try to feel all that it opens unto them.

Throughout the piece you trace histories of colonialism in the area as well as how Korlai exists in the present day, yet this film was created in 2015. With so much having changed in the past 7 years, what do you think would change if you created this film today?

I have revisited Korlai just five times since wrapping up filming in October, 2013. As an outsider, I can appreciate Korlai's inertia and secret indifference to change. Whenever I'm there, I can't help recalling a phrase from the film: "it would always be the same"; and I ask myself: is it really so? The same I might ask of a river, knowing that one cannot step into the same river: asking not what would always be the same, but what might enliven us in our present moment. I'm a different personage today, and now that I'm beginning to get a little more competent with portraiture, I can imagine making something with Korlai's older, creole-speaking residents–in a more familial, quotidian, 'pluralized I' sort of way– but I have no way of knowing what to expect.

Throughout the piece we hear the narrator telling us the story in Korlai in thoughtful prose. Tell us about the narration.

The voice-over narration was the last piece of

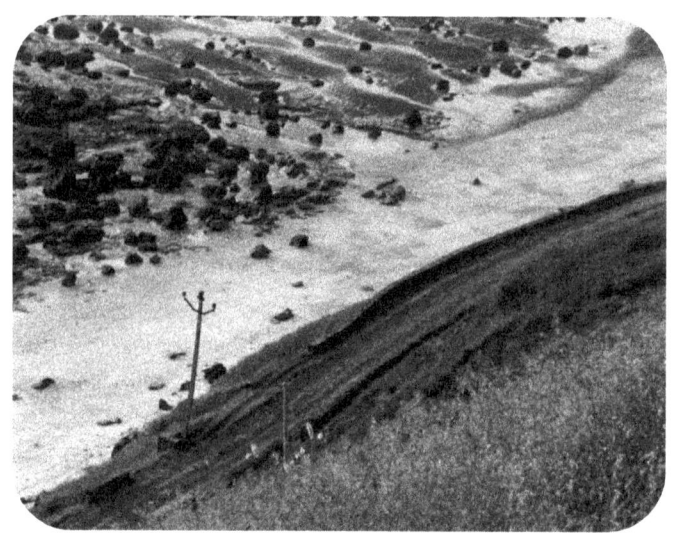

the puzzle to be solved. From the onset, I was relying on haiku-like annotations during research, filming and editing. It was a slow process, taking more than a year, during which the footage had acquired a certain archival quality for me to begin responding to the images in a more removed reflective tone. My first task was to start marking intervals between the impression and the expression coursing through the footage; the interval being a function of both time and permeability, more like an intertidal zone than a diaphanous membrane. The narration was intuited from editing the footage without sound, which not only revealed such intervals but also helped me arrange the key themes (for the voice to play variations upon, later), practically giving away the whole structure, including some passages where the best option was to use a stretch of black leader. In the meantime, my short annotations had gathered some more narrative debris, including literary quotations and my own musings; the existent and the felt, detritus of memory, all held together by a certain overriding emotional charge, a churning of consciousness. When I was in doubt, I took comfort in poetry, especially Eliot's Four Quartets for its composure, rhythms and sense of cosmic time. I was inexperienced and I wanted to say everything that needed to be said, all in one film, as if it were my last.

You mention exile and belonging as two themes in *Letter from Korlai*. How did you strike a balance between two very different experiences?

Broadly speaking, the film is structured as two halves separated by a prayer. The first half, the sparser and more elegiac of the two, traces the exilic experience as a melancholy spiritual rupture, while prospecting for revitalizing material signs and images to moor slippery ideas such as oblivion, memory, desire, distance and time. One can apprehend the narrator's alienation when he returns to Korlai as an outsider, driven by emotions that he

is trying hard to understand, wishing for oblivion, yet oblivious of self-acceptance. Here I'm reminded of a disarmingly honest assessment of human frailty by the renowned Swiss physician, Paul Tournier, who wrote: "At the heart of personality is the need to feel a sense of being lovable without having to qualify for that acceptance." Belonging is acceptance. Thus, eschewing any preoccupation with loss, the second half contends with Time and Terra Firma to find belonging in gnarled interrelations and plenitudes. As landscape, people, ritual and ruin are regarded with equanimity, a regime of the possible is invoked. Wanderlust subsides, new roots sprout, and the sea becomes a transcendent bridge between the mortal and the divine.

In the film you switch between color and black-and-white frequently. Can you tell a little bit more about this choice?

While it's true that switching between color and monochrome can induce subtle shifts in energy that may have a direct bearing on our attention and experience, my choice is largely determined by the suggestive possibilities of the footage. In this film we have used about 2 minutes of black-and-white imagery, most of which was edited into one sequence, leaving just two floating shots that were later grafted as intervals between color sequences for their very peculiar poetic resonance. One of them arrives mid-way into the film, near the end of the church sequence: the serene face of a woman praying, in color, as she closes her eyes; to the washed-out expanse of the sea, in monochrome, with a tiny fishing boat sailing away in the distance, against the wind; and back to color, to the striated shore, from high above, on a luminous day at the beach with cattle grazing. There is so much emptiness and emotional release transpiring in this three-shot circuit that it is well worth revisiting to trace for yourself the forces or intensities that are stoking this perceptual, spatial, transformative shift.

Why was it important to tell this story as an epistolary travelogue?

I had first visited Korlai in 2010, and I had a friend who had also been there, unbeknownst to me. We used to write to each other about life and cinema and languages; once, we had even confessed that we must return there to comprehend its mysterious hold upon us. It wasn't until 2013, that my diploma film research brought me back to Korlai, during monsoon, but by then my dear friend had disappeared from my life. On my sojourn, as I followed what the land and the sea gradually opened to me, along with all the digressions and temptations to deviate, I realized that my thoughts and feelings, radiating from Korlai, were unbound by my surroundings. I didn't know exactly what was going on, so I had to explore it by making a film that was free from all expectations, not unlike writing a letter that might well never be sent or dispatching a postal card to Whomsoever It May Concern. Everything unravelled from there, in cognizance of the primacy of enduring simultaneities and the possibilities of experiencing. It reflects in my choice to (sub)merge the experiencer 'I' into the second person singular 'you' in the narration. Maybe it is also hinted in the practicality of voicing it in English, which is, in many ways, an act of translating myself. Thankfully, I found the travelogue-letter-essay form most accommodating for my aims and my needs.

How did you create the soundscape for this film?

Anachronistic contrast was essential to harnessing the inherent memory-archive potential of the grainy 16mm footage. The layering of sounds proceeded from the recognition of an asymmetric ontological separation between the voice and the visual. The passing of voice–its presentness, focus and textural clarity–had to be reasonably and variably distanced from the persisting buzz of the visuals in order for the soundscape to emerge as an autonomous layer conducive to reflection. Together with my sound designer, who also composed some electronic ambient music for the film, we jacked in a Neumann U87 studio mic to record my narration as clearly and dispassionately as I could voice it, in one long late-night session. The result was a rather pensive unhurried performance around which other atmospheric details were then arranged–including the music by one of my favorite artists, Leyland Kirby (AKA The Caretaker), that vivified the spectral dimensions of some sequences. Finally, during mixing, we went for a steady riverine flow, keeping things on the softer, quieter side.

What's your favorite film stock?

Fujifilm Eterna (both 250D and 500T) for its exquisite balance of rich contrast and toned-down colors. Having enjoyed working with it on my older 35mm short, I was keen on filming Letter from Korlai on Eterna but by mid-2013 already it was unavailable in India. Eventually, we found Eterna Vivid (500T) that infused a bolder palette with lush greens and melancholy blues.

Did anything surprise you while making this film?

There were quite a few surprises, but I think the most serendipitous moment happened on the second day of filming when, while changing our Arriflex 16SR II's magazine, my cameraman noticed 200 ft of unexposed Kodak Eastman Double-X (7222) negative pre-loaded on one of the spares. It must have been prepared for some first-year student's continuity exercise, but now it was destined to serve our vision of Korlai. We agreed to use it sparingly, saving it for that 'grey day' when we scaled the promontory's grassy windward slope. We took turns exposing it, imagining what-if the pictures on this roll were to be the very last memories of a traveller who had visited this place before disappearing without a trace; and we had stumbled upon that film roll now. Most of this high-contrast black-and-white footage was edited into a sequence, narrated as "the first encounter–one of those grey days that no longer ring a bell". In hindsight, it's a fair account of how a serendipitous experience acquires fictional resonance, and how the ensuing elemental frisson becomes an interval, as the encounter transforms into filmic experience.

Anything else to add?

There is a name missing from the end credits. I'd like to fix that error now by thanking Rebecca Solnit for her inspiring meditations on 'the Blue of Distance' in A Field Guide to Getting Lost.

TRENGELLICK RISING
TRENGELLICK OW SEVEL

A CORNISH LANGUAGE SHORT FILM

COMING SOON
OW TOS YN SKON

Trengellick Rising:
A Cornish language short film and deep dive into a cinematic rabbit hole.

Essay by Guy Potter

Trengellick Rising is a Cornish language short film. Shot in Black & White 16mm, it was then hand-developed in a makeshift darkroom using industry-standard chemicals and timings (provided by Kodak), but in a unique way, resulting in a very much not industry-standard result. This was deliberate: the combination of lab-standard chemicals in a DIY process resulted in a scratchy, rough around the edges negative which further complimented our 1700s-set story. A deliberate attempt to transport the viewer back to that era through format, by not being "clean", but also being as good as we could make it in terms of image to make it watchable. The result is something that was shot in 2021 but looks like it's from 1921. The images are stark, incredibly vivid and instantly recognizable. They stand as testament to the hard work and dedication of our team, and the bravery to see that ambition through on a large scale. This is the story of that journey, with the hand-processing strategy laid out in full.

Origins & 'Prey'

I conceived the idea for 'Trengellick Rising' in late 2019 after a Sundance 'Co//ab' class, where I screened a 90 second short film I had made on assignment to much success. On the course in question we were all given a script, the same page and a half of dialogue and were told to direct it as our final piece for the course. The story was deliberately sub-par & bland, for our directorial vision to 'shine through'. Given the prestige of the Sundance Institute, and my desire to not get lost in the noise, I decided I needed to take that to an extreme. So, I decided that whilst everyone else was certainly going to go down the digital route of using their phones and DSLR's, I was going to go several steps beyond. I had recently seen Mark Jenkin's 2019 film 'Bait', and decided I would try and explore the same approach. I had no idea how to do it but set about trying to desperately engineer that vision within a two-week window. I contacted a cinematographer friend who I knew had an old camera and told him the idea. After some hasty research, we bought two rolls of 100ft Kodak 7222 Black and White 16mm and stuck it in his old Bolex. We metered, rolled camera, and blasted light at two poor actresses in an old cottage. I then tentatively searched for a home-process method, bought a big lomo dev tank, and took a massive leap into the developing unknown. The negative came out not only exceptionally clear and perfectly contrasty, but also pin sharp – we'd done it! However, the first hiccup soon loomed and that was with our scan of the negative: we didn't use an industry standard scanner and the film on a screen looked terrible. Damn. Luckily, we worked backwards and devised that it was the probably the scan, so started

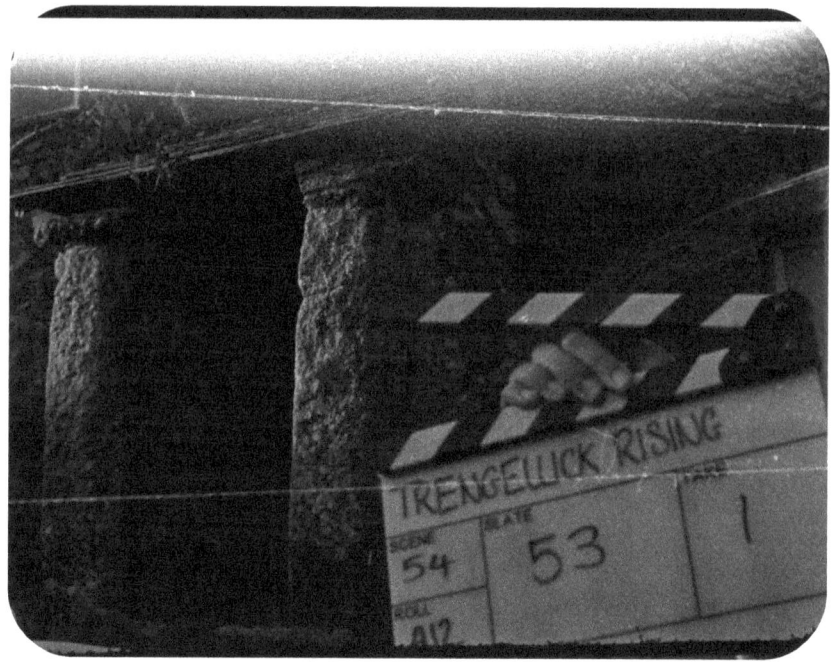

there and sent it to Digital Orchard near London – solved! They were our saviours and their endeavours since have rescued my home-processing journey more than once.

I edited the digital scan on my computer (any further down the manual celluloid rabbit-hole and I'd never emerge), got the actresses in to record some ADR/dubbing (camera too noisy to record sound on the day) and added some post-sync sound. I had in front of me a crude, 90 second, silent Horror short – and boy was it powerful. It was actually quite startling to watch. With some trepidation I took it to the course leaders, and we played the short to the class. The film garnered such extremes of reaction from the advisors and students, that their faces looked like shocked/horrified caricatures when the film ended. I suddenly then knew of how powerful my format decision had been on their experience. It didn't lure the audience down a path to come to their own conclusions, it forced them down it to shocking effect. I was very pleased with the result, but more by their reactions than the film itself – I knew that this method could be utilized to greater effect. With a better script, a grander idea and a more serious film, this could have an even better result. Time to write one.

A Cornish Language Short Film

I needed a script. I needed an idea. How was I going to come up with one? I decided alone time was needed so I set about walking in the very early mornings. Before work I would stride out and stomp intensely, whilst listening to music that matched my mood. I knew the film format was going to be dark, scratchy and intense like 'Prey'. If this format was full of atmosphere, then so should be my story. As I walked one morning, proceeding up a hill with the wind howling around me, I looked up and saw a blank horizon outline – blank except for an old haggard tree on the hill of

the horizon. I envisioned a man stood there, coat blowing in the wind. My mind was taken back to another century, another world, full of darkness and moody foreboding. I spun isolation as a theme around my head and put myself in the shoes of someone seeing that image of a man on the horizon, and how afraid they would feel in that situation… so I played on that.

Weeks followed and various more visualizations came to me. Soon I had the basis for a story that explored isolation, fear and dread. Wild landscapes and crashing seas that were steeped in dark history. I decided to set the film in the 1700s and thought that Cornwall fitted the bill perfectly. The ideas and imagery then flooded in thick and fast, so I thought I'd try and capitalise on that and make the film as soon as possible – then the Covid-19 pandemic hit.

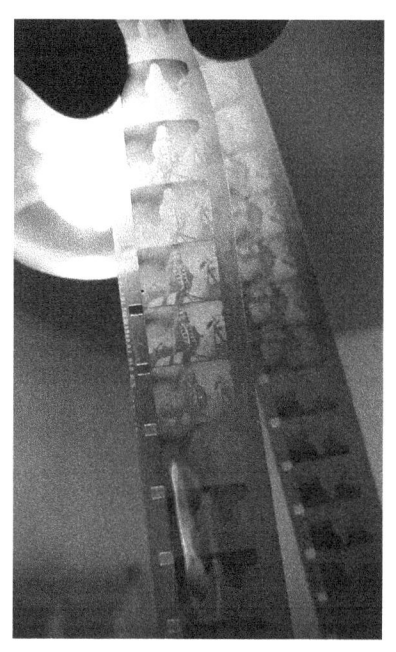

I put the project on hold, isolated myself with it, and got to grips with a new reality. Someone said once that in order to thrive, first you must survive. Being a 'shielder' and someone who may have been clinically extremely vulnerable to the virus, I did that first. Looking back on it, I needed a pause and a step back from the project – to let those wild ideas and visuals mature. One year and a lot of revisions later, I had a polished project: I had characters, story arcs, locations and themes. I'd shot some test footage, bought several new (old) cameras, rebuilt one from scratch that matched our potential demands (an Arri 16ST adapted to use V lok batteries & various modern mounts) and was ready to go – but something was still missing. The film still wasn't… enough. The format was fine, but people had seen it before. It needed to be something new, as well as old. In a moment of madness, I thought… "well it's

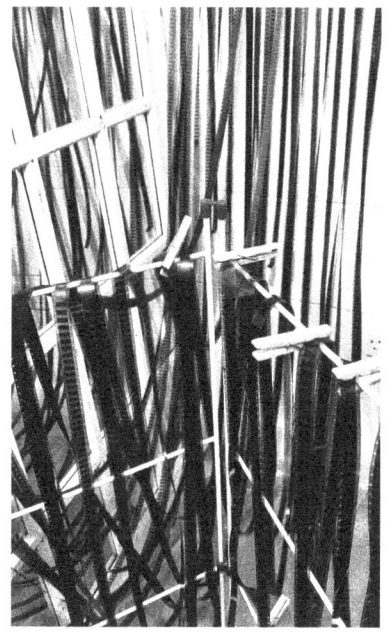

set in the 1700s, in Cornwall... why can't it be in the old Cornish language?". One mad thought and a Kickstarter campaign later, the project smashed through 145% of the intended budget goal and I was onto something - with hundreds of backers who agreed with me.

After a few days of getting my head round that support, I reached out to the Language Department of Cornwall Council and the filmmaking department of Falmouth University. Very soon I had a completely translated script and a crew willing to help. The cast came together, and we spent months learning the language with Cornwall Council's language department. Through audio recordings and zoom sessions we brought an old language to life. We devised a plan, came up with a schedule, booked a block of days for filming, and before I knew it we were on Bodmin Moor in the howling wind - with a 60 year old camera, over 3,000 ft of 16mm and crew of 10+ people making that vision of a lonely figure on the hill a reality. What a wild run of events.

'Trengellick' Rises from the ether.

The shooting was a success. In just under a week we captured over a kilometre of 1700s Cornwall on film. We laughed, we cried, drank some beer and were fairly traumatized – but we'd done it. We'd made that vision a reality and (hopefully) captured it all on film. The dust settled and I stuck 33 rolls of 100ft 16mm in the fridge, plus some test footage. People say the best thing you can do when you've become too invested in something is to take a step back and get perspective. I'd done that a few times on this, so I did it again. But this time the pressure and the dread of the film in the fridge started to play on my mind. I started to worry, an intense fear came over me that all that effort and all that money had gone down the drain. I'd have nightmares

and a creeping fear that maybe something had gone wrong and that all the film in the fridge was blank and I'd led everyone up a very extreme garden path. The only thing I could do was try and remember the process I'd done before on 'Prey', try and fine tune it and develop a roll as a test – a terrifying prospect.

So, I did more research, spoke to Kodak, furiously got my ducks in a row trying to preemptively not make any mistakes and ordered the 'chems': Kodak's D96 made by another company & Kodak's F5 Fix, which I then swapped out for Fotospeed FX30 Odorless Fix diluted as I could get more out of that. I'd had problems in testing with my larger dev tank, and an inconsistency with a 'flashing' negative on the scans due to botched agitation, so I bought a new, smaller Lomo tank and sat there trying to learn a new, more accurate method. I asked around and did lots of dry runs, memorizing everything so that I could do the whole process in the pitch black – one thing about this flashing issue was to eliminate issues and one of them very possibly could be light leaks, so I treated the entire bathroom I'd commandeered like a giant dev tank as per Kodak's recommendation (they're a lovely bunch). I engineered a dynamic where I could load the tank next door in a spare room of my house in the dark, which enabled me at the same time to be able to prep the chems next door in the bathroom in the light. Much easier than all in one room as before. I pre-warmed containers & tanks, filled 'wash' buckets, adapted various vessels to be identifiable to touch, laid everything out, switched off the lights and slipped next door to grab the film (now loaded onto the spiral and bundled up in bin bags & towels for brief transport). With the general light levels dingy in the house, I snuck back into the bathroom, closed the door, pulled the curtain over door frame and sat still in a pitch-black void of nothing. I slowly unravelled the towels and bin bags, took the film out, steeled myself for what I was about to do and began.

I split liquid, made a mess of timings, knocked things over and dropped essential tools. However, I made it through. Towards the end of the process, desperate and afraid, and whilst the negative was 'washing' with door ajar (as Kodak said it was light-safe then either way) - I snuck a look - I had an image! I washed it, treated it with wetting agent to reduce dried water spots and hung it up to dry. Hanging loosely on an old clothes horse, the film displayed it's secrets and I poured over the thousands of tiny images, a snippet of a film in their own right playing in my head. Over the next three months I slowly gave it a go, making lots of mistakes and making a lot of tweaks. Below is a very summarized method of that process that I fine tuned through relentless trial and error. I've written it out in step by step detail so that if you want to, you too can attempt the same. Take it with a pinch of salt, as not everyone will want the image I got, but if you do and you want to experiment, then it's all below. It's phrased a bit like a kitchen recipe, as that's exactly what it was.

Recipe & Process

Firstly, lay out your various vessels, get familiar by touch: big warming bucket, dev, fix, wash bucket, tank, funnel and timers. Do the same with loading your tank in

your alternate room/space also. Be super organized – I wasn't to start with, and my results varied. Stick to the plan fanatically and you'll see some consistency (hopefully). Make sure all your kit and chems are there, pre-mixed and in the exact same place every time so they can be found by touch in the dark. Get your wash bucket prepped and make sure it's full of water, around a non-offending 20°C. Pre-heat the developer and the fixer using it, (for me that was getting them both to 21°C), in their own vessels, by heating/cooling water around them. Pre-heat your tank with 21oC water too so when the dev enters it, the cold tank doesn't immediately cool it – these times and temps have to be to within a degree or quarter-minute throughout, or your final image will differ, so get them exact.

Get your layout ready. Make sure you can empty a full dev tank back into it's original vessel and make sure you can do that in the pitch black and not mix them up (scary). Think everything through and have a route to take through your various buckets and tanks. Get it all in order. I found to wash the film prior made for a more consistent Dev as everything was already wet when you poured the dev in – but that's just it – don't pour anything in on top of the film! Have it already in the tank, lid open and lower the film in, instantly, so all the water/developer/water/fix/water hits the negative at exactly the same moment for each stage… told you that you need the room to be dark/light safe.

Here we go: make sure everything's at temperature before you turn the lights off (wash/dev/wash/fix), wash water ready, dev in the tank, both at the right temperature. Lights out and away we go. Bring the film in, close the door and seal yourself off. Place the loaded film spiral into a separate bucket of 20°C water, wash it for 2 minutes. Agitate throughout, let it settle, extract the film. Shake it off, prepare the timer… and lower it all at once into the dev, rotating it gently as you do so (don't spin!). Prod the timer as it hits the mix (good luck working out how to get a timer you can read in the dark without it illuminating the room) and agitate up and down furiously getting all the air bubbles for the first minute – less bubbles less air - more developer on the

neg. Whilst we've tried to negate any potential light leaks by sealing the room we need to be completely sure, so put the lid back on the tank. Then, settle in for routine agitation and relax – but don't lose track of time and don't turn the lights on! Over an 11 min dev (your times and temps might be different), I found that agitating every minute was easier for me than 30 seconds, as I'd lose track of time, and get surprised when the timer went off. So, on the minute I'd do 10 secs of agitating: moving the spindle connected to the reels in the Lomo tank slowly NSEW like a compass and then shaking it up and down gently, followed one slow rotation (don't spin!). Continue for whatever your time is. Within that time, you must replace the water in your initial wash bucket, or perhaps have a second bucket (why didn't I think of that at the time?), you'll see why now: Timer goes off, lid off, extract in one go, plonk it down quick into the wash bucket for two mins, empty the dev out of the Lomo tank back into it's container in the meantime and rinse the Lomo (yikes), pour the pre-warmed fix in, reset the timer, and repeat the above, same agitation – equally important. Easy right?

Apparently you can't fix for too long but make sure you definitely do it for at least twice the clearing time you did on your fix test. You did do a fix-test right? I made the mistake of guessing and not doing that and halfway through my rolls, one came out a horrifying blue ish/clear and I thought I'd wrecked the whole roll, luckily another fix in a new batch semi-rescued it (so test your fix every roll!). Once you're done with the fix, empty the fix out, but keep the lid on the tank this time and immediately pour water in, 20°C-ish temp (though doesn't have to be too accurate). The light sensitive bit is over (according to Kodak) so turn the lights on, now wash the film incessantly. You don't want any fix left over so at least 20 mins of constant flow. New water in one end, old water out another. In the final minute of washing, prepare a jug of Wetting Agent, empty the tank of washing water, seal it up again – and pour that wetting agent mix in. Let it stand for 2 mins, drain it, shake off and move to the drying stage.

Now drying the film is an art in itself (allegedly). I however got a massive elastic band/'theraband' stretched over two screws in the wall and 6 feet away I put a clothes horse out, and I reeled the film out through the theraband and ver the clothes horse, clothes-pegging it secure (be gentle). I could get 200ft on this set up, maybe 300. One piece of advice – put some plastic sheeting down. If the film drops off the drying rack it'll hit the floor and get covered in sh*t. Dust, carpet bits and hair. It doesn't come off unless you wash it all again instantly. Anyway, marvel at your immaculate results and shut the door. Leave it to dry for several hours/overnight. Bask in your developing glory and dream of your future success… or quietly panic about the next batch.

Talking of panic, yes I botched a few things along the way. Some of the solutions are included above, some not so obviously and it's hard to remember. It was a hazy experience, probably the chemicals to blame for that.

Here are some warnings:

1) Do not chance your dev and stretch it's usage too far. It will expire, and it will not be obvious – then suddenly one roll will be completely blank (it happened to me but luckily it was a "day for night" scene anyway and Digital Orchard are wizards). Whatever your expected usage levels are, half it. Usually the darker the color the weaker it gets.

2) Test your goddamn fix. The last thing you want is half-fixed results and the negative to all wash away, remember fix is "fixing" the image to the negative, if that's exhausted you will watch your images literally go down the plug hole. Don't be lazy.

3) Practice, practice, practice. Or shoot test, test, test. Try and get your mistakes out early.

4) Get a really long and accurate thermometer, a brewing one that's all glass – not digital (will get dropped in at some point and break).

5) Get good timers/clocks – get few of them and then some more. Have more than one on at once. I had a few run out of battery/get way/go blank, and when you've lost track of time in the pitch black and you've no idea where you are in the timings - it's time to scream/pray.

6) Strike up a good relationship with your scanners and Kodak, they are your best friends and the only people you can turn to when sh*t hits the fan.

7) Fix is fix but you want to try and get a neutral/non-alkaline fix to preserve the image should you need the original neg in the future. You can dilute fix, it's fine. Just make sure you test. I found one batch of fix would last 200ft, then I'd chuck it away.

8) As in Dune, don't let fear be the mind-killer. Film is forgiving, as is Black and White developing. A few stops either way isn't the end of the world, but don't get too relaxed or your aspirations of a good final film will stay as aspirations.

9) The Lomo 16mm tank is 100ft capacity. The reels from Kodak are 106ft, designed for 3ft of light exposure at the start and the end as you load/unload. You'll have to cut 6ft off to get it to fit the Lomo and you need to dev those separately if you want to keep the images on them – unless you were wise and didn't shoot anything important in those bleached and distorted 6ft sections. Whoops. (Side note, whilst that was stupid to do in terms of potentially missing takes & narrative out as a result, those sections are by far the most interesting sections of quirky mad film. People would point those inconsistent bits out first, marvelling over them when I'd play back the rough/proxy scans and I soon joined them – in the end I included every one of those sections that worked in the final edit.

There you have it. I hope that all that makes sense and I hope it didn't put you off. Give it a go, get wild, enjoy it and reap the rewards. You'll create original cinema and once you use film, I think you'll find you'll never go back.

Exact times & temps:

D96 Developer @ 21°C for 11 minutes

Fotospeed FX30 diluted for less intense fixing time (more time to agitate consistently therefore less quirks) for 11 mins @ 21°C

This information/conclusion alone took hundreds of pounds and hours to achieve.

Conclusion

After several months, a fair amount of investment and a big labour of developing-love later we have a film. The edit is running at 35 minutes and we have a long-format short film. It plays out like a condensed feature film. That's intentional, as I know it will escape a lot of film festivals as a result, but it makes it better for screenings. Here in Cornwall, screenings
are more important to me than far-flung festivals around the world, as the language is based here, and I want the people here to be able to see it. We'll do showings with Q&A's and make an evening out of it.

As I write this, the film has taken shape, we have a first-cut and it's about to head to sound, ADR and dubbing. We're looking for release late autumn, and if you'd like to stay in the loop then just go to www.trengellickrising.com or follow it on social media, Instagram, Twitter @trengellickrisingfilm – that or just give a google now and again. Feel free to ask me questions about what we did anytime via the channels above.

Oll an gwella // all the best

Guy Potter

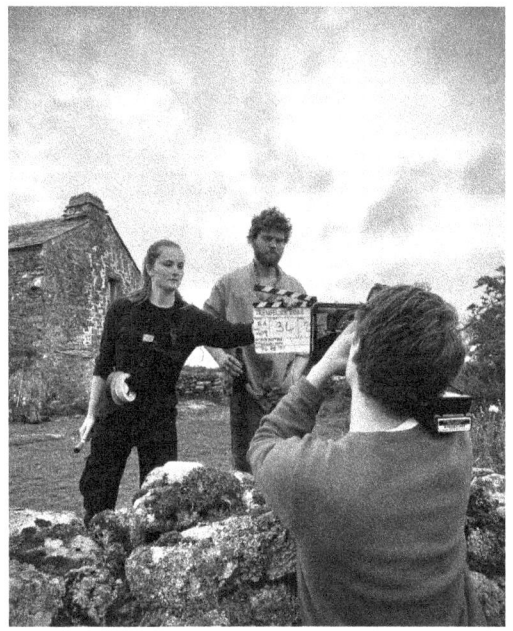

Building an Edge
Britany Gunderson

35mm moving image
made with a LomoKino
camera

This is your second time being featured in Analog Cookbook. What's changed since we last talked?

Yes! So happy to be featured again. Since then, I've graduated and received my Film BFA, traveled to a few film festivals (including Festival Tous Courts in France), attended an art residency, and became a full time tattoo artist!

Tell us about *Building an Edge*. What inspired this piece?

I created *Building an Edge* at an art residency in Cisco, Utah called Home of the Brave. Cisco is a ghost town with a population of maybe 3 people? But the founder and creator, Eileen Muza, built up this amazing space for artists in the middle of the desert with various old campers turned into studios and whatnot . It's very remote. I was first inspired by the camera itself, the LomoKino, and seeing what I could actually do with it. Then I was inspired by the landscape in Utah and exploring it. I proposed shooting on the camera before I knew exactly what it would look like or if it would even work at all. Then spent the duration of my residency shooting the sprawling landscapes and reading Edward S. Casey's The Edge(s) of Landscape: A Study in Liminology.

Why did you decide to shoot on the LomoKino?

I had never heard of a LomoKino until I found it at a thrift store in the middle of Wisconsin. It came with a little booklet and explained the process of it, taking regular still-photography 35mm film, turning it sideways, and hand-cranking the camera as fast as you could to create a stop-motion effect with the film. I found out later that Apichatpong Weerasethakul also made a film with the LomoKino. This camera ended up being my way into the residency and landscape surrounding it. I thought it would be a non-traditional way to capture my surroundings while still exploring and figuring things out.

In *Building an Edge*, you switch from shots of the desert to tactile elements that obscure and dance over the image. What was your process like making this film?

While shooting, my images were often influenced by the idea that I would embroider over the image. After it was all developed, I scanned the film first with my 35mm film scanner, then was a little hesitant to embroider over the film since it was all I had - the original negatives. I wanted to stretch out my imagery, squeeze as much as I could out of the 6 rolls of 35mm film. While I was in Cisco, I found many little objects preserved for years by the desert: glass bottles, folders of papers from the 1960s, and remnants of homes. I collected these items and

placed them over my film strips as I scanned them frame by frame, trying to bring dimensions and tactility to the landscape.

How did you create the soundscape for this film?

Almost all of the soundscape was field recordings around the area. I spent about a week gathering sounds on my Zoom recorder, finding as much as I could. There was a point when I felt like I ran out of sounds to record. It's very quiet in the desert by yourself. Then it all came together in the edit.

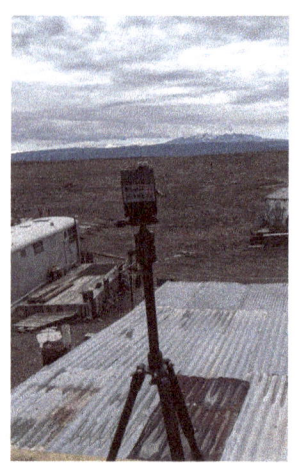

What film stocks did you use? Was this all hand developed?

I used 35mm Fujifilm Color, I think it was whatever I could find at Walmart. And no, I drove into Salt Lake City to get my rolls processed, certainly the cheapest film on film I ever made!

What was your favorite discovery making *Building an Edge*?

There were a few big discoveries. First was actually seeing the film after it was developed and that it actually worked and that I didn't make some disastrous mistake. Second was the process of scanning the film and seeing that I could place the objects over it and in the scanner, it created some effects like I had never seen so I had so much fun experimenting with it.

What's next for you?

I'm starting a new film about cats and breakups!

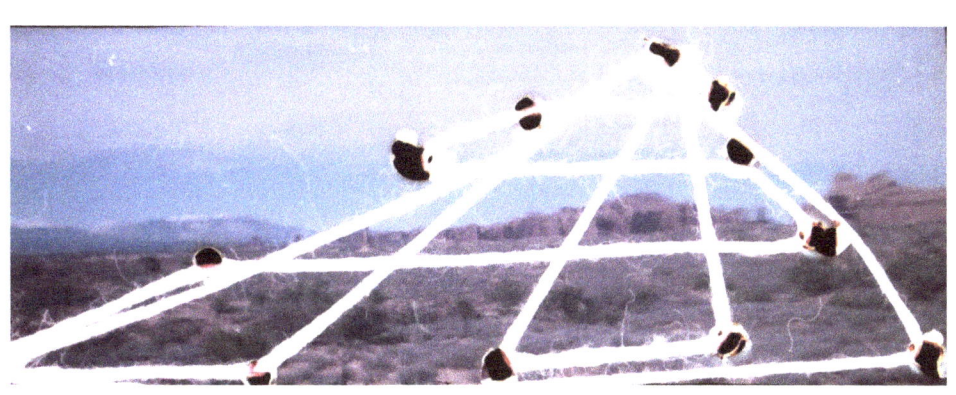

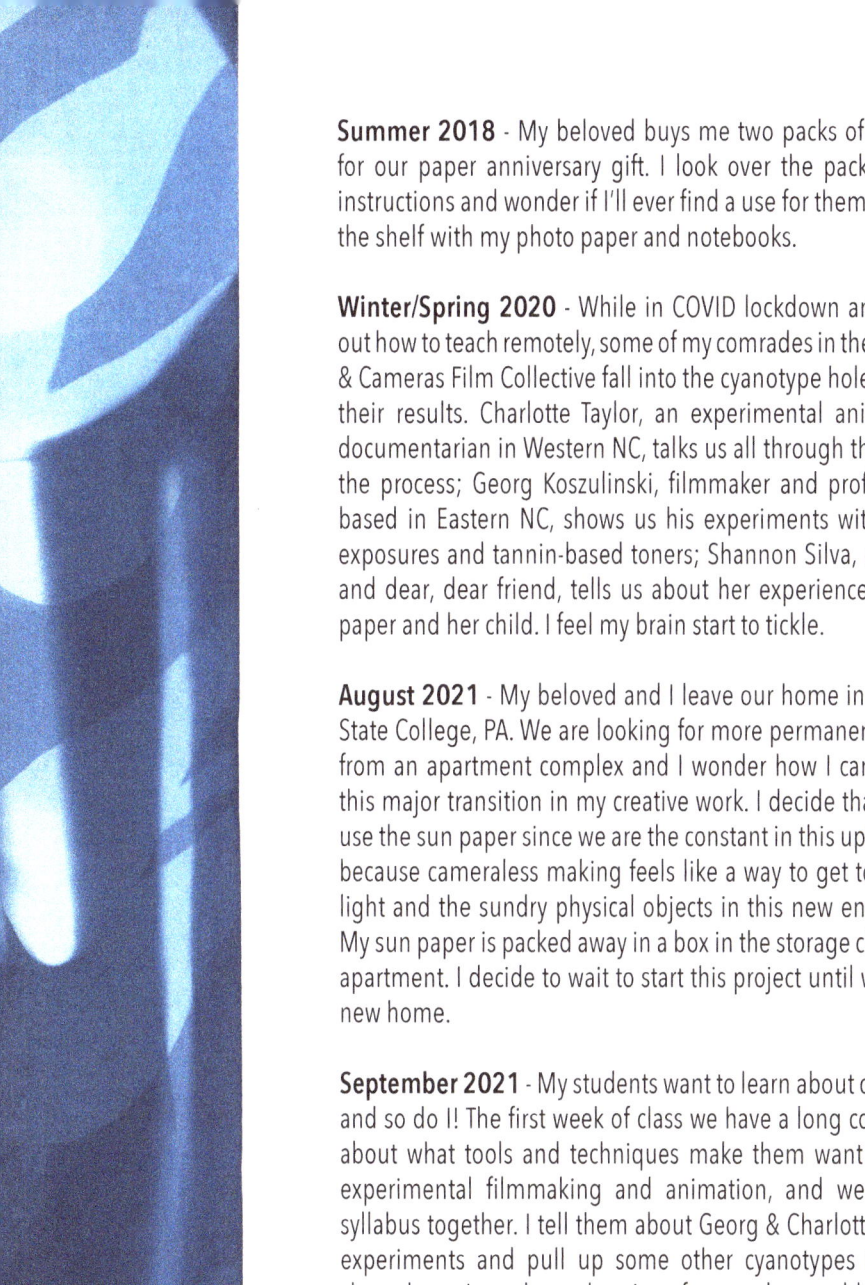

Summer 2018 - My beloved buys me two packs of sun paper for our paper anniversary gift. I look over the packaging and instructions and wonder if I'll ever find a use for them. It goes on the shelf with my photo paper and notebooks.

Winter/Spring 2020 - While in COVID lockdown and figuring out how to teach remotely, some of my comrades in the Hammers & Cameras Film Collective fall into the cyanotype hole and share their results. Charlotte Taylor, an experimental animator and documentarian in Western NC, talks us all through the basics of the process; Georg Koszulinski, filmmaker and professor then based in Eastern NC, shows us his experiments with multiple exposures and tannin-based toners; Shannon Silva, my mentor and dear, dear friend, tells us about her experiences with sun paper and her child. I feel my brain start to tickle.

August 2021 - My beloved and I leave our home in Boston for State College, PA. We are looking for more permanent lodgings from an apartment complex and I wonder how I can/will mark this major transition in my creative work. I decide that I want to use the sun paper since we are the constant in this upheaval and because cameraless making feels like a way to get to know the light and the sundry physical objects in this new environment. My sun paper is packed away in a box in the storage closet of the apartment. I decide to wait to start this project until we find our new home.

September 2021 - My students want to learn about cyanotypes, and so do I! The first week of class we have a long conversation about what tools and techniques make them want to explore experimental filmmaking and animation, and we build the syllabus together. I tell them about Georg & Charlotte and their experiments and pull up some other cyanotypes in class to show them. I purchase chemistry for our class and begin some preliminary experiments on embroidery fabric and scrap paper. It takes several failures, but I figure it out and we take two class days to give it a try. The students are excited about the results and the process, and I am, too. Our dean comes to visit and

Gabby Sumney

takes some pictures. The experience inspires me to set the limits of my own experiment:

Every day for an entire year, I will make a cyanotype. I will only use the sun paper as my base (30 pieces of paper). (1) Expose the cyanotype & process; make process notes on the back, (2) Take a hi-res scan of the exposure, (3) Apply cyanotype chemistry to the processed and scanned print, (4) Expose the new print on top of the old print, (5) rinse & repeat. Each print will have 12 exposures by the end of the calendar year.

October 2021 - We move into our home and adopt a puppy. I begin furiously unpacking my studio to find the sun paper and other goodies and start dreaming up a dark room plan for the basement.

November 2021 - I pitch my plan to my comrades. They are excited and have suggestions for how I might make this a motion picture film. Together, we brainstorm how it might exist in its final state–as an installation, film, or something else entirely.

December 2021 - I start with the sun paper. There isn't much sun because of the winter of it all. More than once I mess up exposure times and accidentally happen upon some interesting effects (shadows, rain speckles, etc). I start with houseplant leaves and other items that I happen upon. I break a picture frame trying

to get items pressed flat against the print. Around the 20th, I start batch scanning, and decide to fake film strips out of the prints by selecting 23 lines and the full print on the scanner. By the end of the month, I have 744 images to bring into AfterEffects. Mostly processing the prints using water from the basement dehumidifier in a bus tub we acquired from our wedding venue.

January 2022 - First month of multiple exposures, and the first few days were tough. The chemistry has a different exposure time than the sun paper. I figured it out. I also figured out an animation scheme for December scans. Hogan Seidel (yep, this one) and I talk through the sound possibilities. They get a workflow from filmmaker/photographer Bridget Connell to convert visuals to sound similar to the way that 16mm projectors read sound from the film strip. Hogan does a quick version for my December animations. I shared some clips with my comrades who are excited to see what develops. There is a vocal contingent (Shannon & Hogan) who want to see this as a feature film.

February - March 2022 - Settled into a workflow. Played with different items and textures. Starting to think about toners and other ways to disrupt the look of the animation. Sent Shannon Silva a copy of her birthday print as a puzzle by using one of those print services people make calendars and greeting cards out of. I almost made it a mug, but Shannon made the mistake of telling me how frustrating puzzles are once they are more than 500 pieces–as an avid 1000 piece puzzler I feel the need to defend the honor of puzzles everywhere and being irritating is my love language.

April 2022 - Toner experiment #1: washing soda. A month of yellow prints using washing soda (1 tbsp: 1 L of water). The yellow prints are gorgeous. I use my research funds to buy a contact print frame, more chemistry, and other items to help this process along.

May 2022 - Was going to try another toner this month, but I like the look of the two-tone prints with blue & yellow clashing. Start intentionally collecting plants from the garden as a way to really cherish the beginning of spring. I send Hogan Seidel a digital copy of their birthday print so they can make a print of it for their new studio.

June 2022 - Experiment and fail with sulfuric acid. Read Cyanotype Toning: Using Botanicals to Tone Blueprints Naturally by Annette Golaz to consider other toning methods. Start with grass clippings from the yard and try as many new plants as I can find. Start a spreadsheet to track results. Change the scan pattern to mark the beginning of the second half of this project. Taking our first long vacation since moving here and traveling with the cyanotypes is fun. Lots to tone when we get home.

July 2022 - Changed the scan pattern again for July. I think I'll do this every month until the end of the project. Continuing to play with botanical toners both using garden plants and dried herbs & spices in the kitchen. More changes in my personal life that I can tell will impact this project as it comes together in motion picture form. Collected voicemails and memos and field recordings from this year so far to integrate into its eventual sound design.

August 2022 - Looking ahead to the end of this project and wondering how much I'll miss it when it's done. I think the daily task method really works for my practice–in some ways it functions like a warm up exercise to get me thinking about my work. It's become the art practice version of my morning cup of coffee. I know I have to do it when I have the light that I want (usually between 9 & 10 AM to lay the print on the back deck but afternoon light until about 3 if I'm willing to lay the print in grass). The fact that it's something that I'm still figuring out means that it's challenging, but since it's a daily ritual it also means that it's low stakes. If I mess up today, there's always tomorrow. Plus, the openness within a relatively small number of set restrictions means that I get my mind to work often before I set out to complete my BIG art task of the day whether that's teaching, writing a proposal, editing a film, or making images.

I certainly don't think I'll stop experimenting with cyanotypes once the year is over. Things still left to try: (1) turning a Kodak Carousel into an enlarger, (2) other kinds of paper and materials as the base for the emulsion, (3) so many different botanical toners, (4) different animation workflows and sequences, (5) Golaz's methods of tritone printing of stills, (6) weird concepts that will certainly occur to me while I'm in the shower.

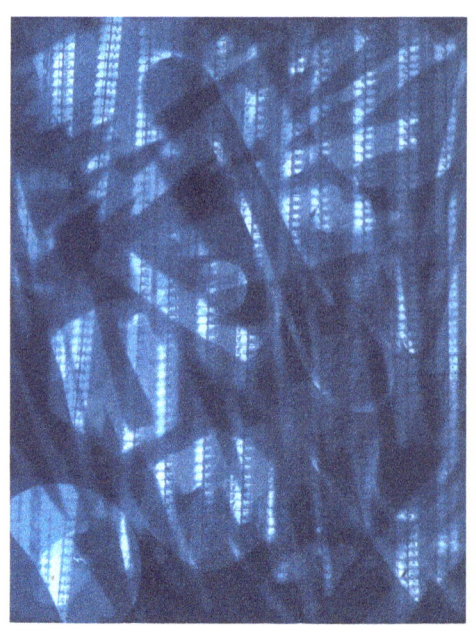

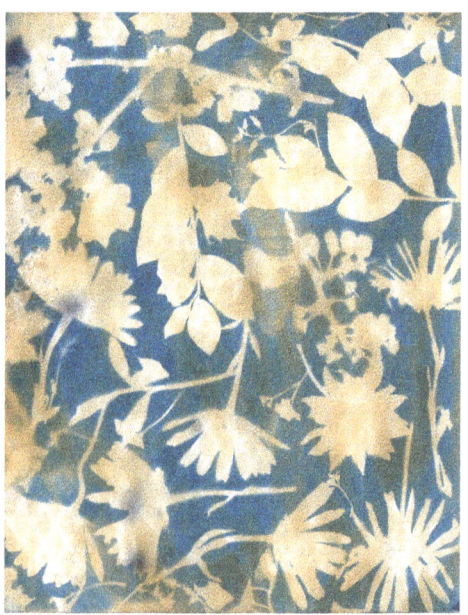

Plant Name	Amount/Volume	Toning Time	Kitchen Sink Water	Sink Water + Calcium	Fridge Filtered Water	Notes
Asparagus (woody stem)	25g	1 hour	Bleached gray/turquoise			Next time, double the mass
Brussel Sprout (leaves)	25g	1 Hour			No impact	In a muslin bag; no change on bleached paper;
Brussel Sprout (leaves)	46g	1 Hour	Light Blue/Slate gray			Loose in the beaker strained with fine sieve, combined once steeped leaves with unsteeped leaves at an almost 1:1 ratio; slightly bleached unbleached paper
Celery, leaf	25g	1 hour	darker blue			
Clipped Grass	25g	1 Hour			Gray/Turquoise Split	
Cucumber, leaves	25h	1 hour	grey			
Fern	25g	30 min	Brown			Bleached print with blue still intact in places
Lettuce	25g	1 hour	lighter blue, green stain			
Lungwort	25g	1 hour	Darker blue			
Oak bark with lichen	25g	1 hour	grey			
Oregano, fresh	25g	1 hour	cool brown	dark blue		
Peony Petals, dried	5g	1 Hour	black, dark pink stain			
Swiss Cheese Plant	25g	1 hour	Gray/Black/Brown			Tested on a bleached print
Swiss Cheese Plant	25g	1 hour		Gray/Turquoise Split		Tested on a blue print
Thyme	25 g	1 hour				
Tomato (leaves & stems)	25 g	1 hour				
Basil, fresh	25 g	1 hour	pale brown			

- 12.20.21 - ?'s HERSHEY KISSES (GRINCH)
- 1.19.22 - CANDIES & SNACKS
- 2.18.22 - NANNY'S DAY. CLOUDS
- 3.20.22 - LITMUS DYE TAKES NEW PEROXIDE BATH IMMEDIATELY
- ?.20.22 - CHALK WASHING SODA
- ?.??.?? - OREGANO, THYME, PARSLEY, DAISIES, BLUEBERRY BLOSSOMS, MARIE
- ?.18.22 - RANDOM CRAVES, TONED W/ PEONY PETALS
- ?.18.22 - TEA BAGS & HIBISCUS PETALS BAD EXPOSURE BLEACHED BY WASHING SODA

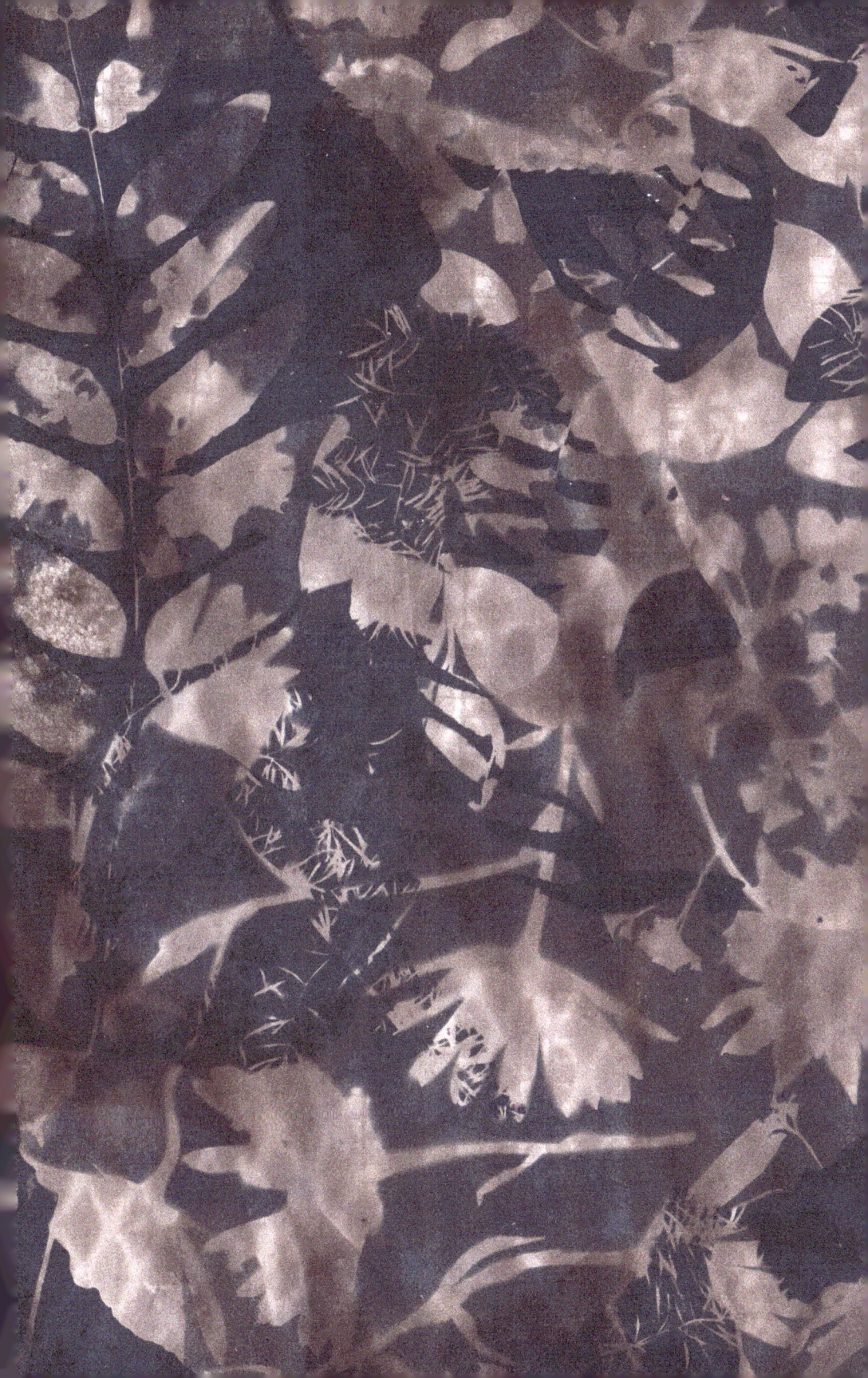

Alejandra Orjuela

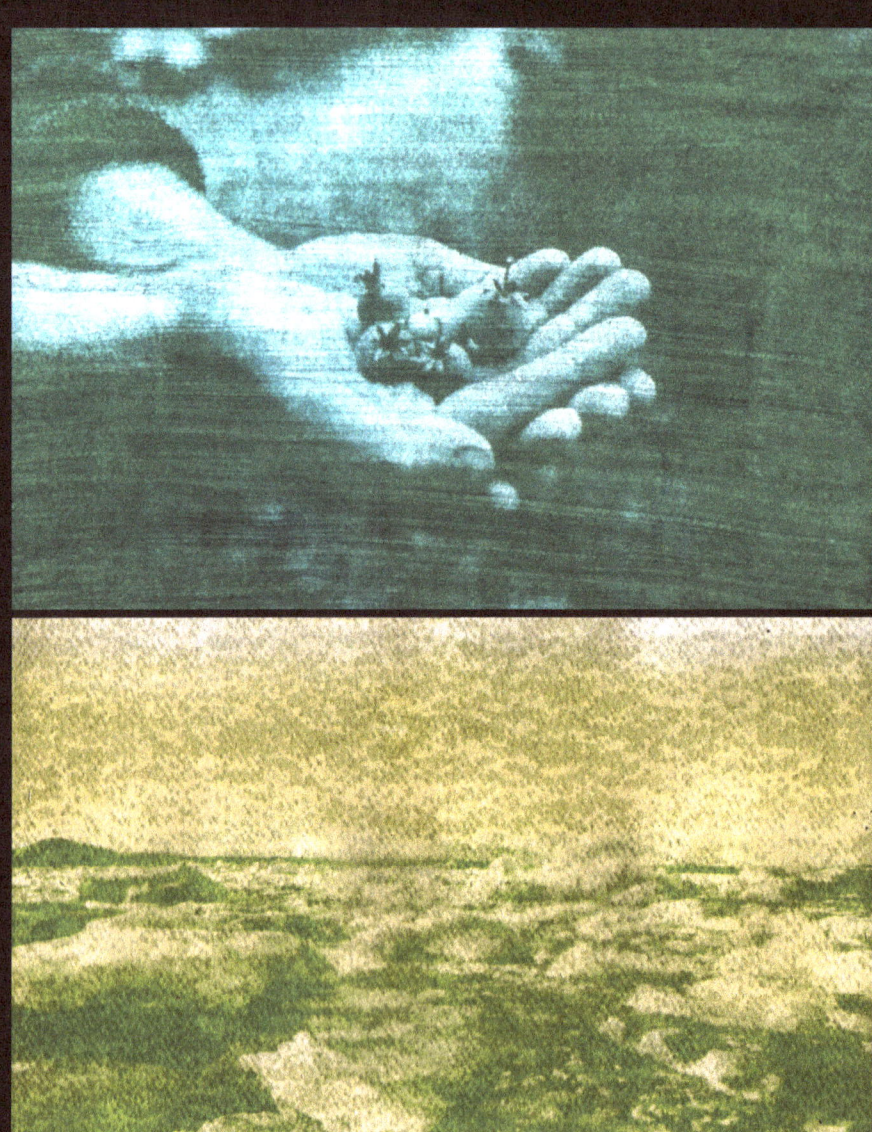

The Garden of Edén: Solar Equator

Iceland: The Land of Ice and Fire

To start, tell us a little bit about who you are and your background in photography and filmmaking.

Well, I've been doing photography and filmmaking for the past six years. I fell in love with analog when I was 16, because that was my first experience with analog in a darkroom. And, from that moment on I kept doing it. My film camera was always with me. Most of the time, I work with everything related to analog. That's what is most interesting to me. I'm really not a fan of digital.

This last series (Garden of Eden) that I've been working on is more on sustainability. I believe that is very important, because filmmaking and film per se, pollutes a lot. I've been researching on different materials, and I found Future Materials Bank. And, they're talking about three different materials—hemp, mycelium made from mushrooms and spirulina, as one of the future foods for people to have a lot of benefits for their health.

They come from this point of bio design where they can integrate easily. They can disintegrate very easily. They don't pollute as much as normal chemicals in photography and film do. That's what I wanted to portray with the series, but it's more like an experimentation.

That is what I came up with, as well as the subject of the series. I was in Ecuador, which is the health of the world. And, so I figure if you're in the health of the world, you have to represent the volcanoes

and the mountains and how everything was born. It's more as a song to the earth and to photography, a series to the earthput in an analog way that doesn't pollute and doesn't contaminate.

I wonder if you could tell us about your process with anthotypes.

It's one of the first processes that were done with the idea of capturing images, because what it does is very simple. It's just the process of photosynthesis. Plants have chlorophyll, and they have this chemical that reacts to the light. What's happening is pure chemistry. That's what I've been doing with the series. What I want to do is try it on handmade paper. With these materials you need to try them out before to see if they actually work. Spirulina works very well. I also use spinach. Spinach is more regular, but spirulina I used because it's a microalgae. It's very easy to grow. And, it's very good for your health, and it's going to be one of the foods in the future.

Thinking about that and putting that together, that's how I came up with the anthotypes, which I thought will be the least polluting process. However, it does have one of the steps that you need to use a plastic plate.

When you're presenting these series with these anthotypes, how worried are you about things breaking down over time or is part of the process?

Well, of course, when you take a picture you want to capture that for a very long time. It is possible. What you can do is steam the paper, but I haven't tried it. I'm not really concerned if the image goes away, because it's part of the emotion. Nature has a process. Nature comes and then dies, and then you don't see it. It's a cycle. The images would be in a cycle. If you put photographs in a space that is not going to have direct sunlight, then it will last for a very long time. Or you can also add Vaseline. You use it like a varnish, and then you let it dry. And, that will take into the paper, and the image will stay longer.

There's a lot of plants that have already been tested to make anthotypes. But the beautiful thing about this is experimenting with new materials. Also making other people aware. I've been shooting film since I was sixteen, but then two years ago, it hit me that the gelatin is made out of animals. This industry pollutes a lot of the world. It just hit me hard. I needed to stop using that much film, and instead come up with something that won't pollute that much. Maybe in the future I can design film to be completely vegan. Hemp can be very resistant, so you can also make plastic out of hemp. That could be the base, and the gel you can be made out of mycelium to make a gelatin that is purely vegan. And, then we need to find a way to make the metals to stay in the gelatin. But there's always things that can be improved in analog to make it more eco-friendly and more beautiful. Because it's already a beautiful process.

Do you have a favorite plant that you use for your anthotypes?

I think right now it's spirulina, because it gives the perfect color. I love everything related to the color of the ocean or that turquoise aquamarine color palette between all the greens. Because it's monochrome. You just have the part that burns and the part that doesn't burn with the sun. It's very beautiful.

You have two recent exhibitions, The Garden of Eden and the Iceland: Fire and Ice. Tell us more about these exhibitions.

I went on a trip to Banos in Equador. When I was little, I was always in love with this poem

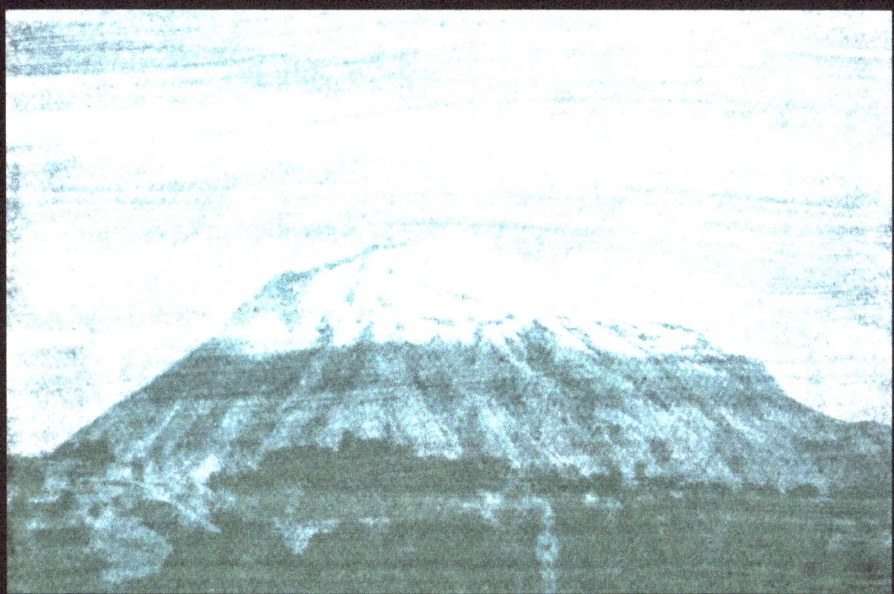

of John Berger that is called And Our Faces, My Heart, Brief as photos. And, it talked about the mountains and how the mountains give life to everything. And, I was on top of the world, and actually the photo with the hands is a fruit that I have never seen in my life. And, I'm from Colombia and I've seen a lot of fruits. I thought it was so beautiful. It was almost like a cherry, but it didn't have any seeds in it. I thought this is the seeds of the mountain it is giving us. And, I thought this is beautiful.

Iceland was actually the first series of my anthotypes. I took a trip to Iceland on 2019, and I was over overwhelmed by the wildness of that country. It's so beautiful. You can take a step, and you can die. Or you can just be mesmerized. It's very big and very beautiful. I felt very connected with that place, the wildness. The world is changing so fast with capitalism and that place might disappear in time.

I also like calling out climate change, because when I went there, there was this glacier that was melting completely. And, I thought, "Well, this is sad. How can I make an image out of this that reflects and is good for the environment, but I can do it in an analog way? Because with digital, that's the thing. You cannot touch the picture unless you're printed, that then becomes analog. But for me, it was more important to make an image calling out the climate change of a beautiful place with materials that could be sustainable that I could reuse.

And, you have a digital component too with the Iceland piece.

Yeah. It was exhibited in the image for climate change in Mexico this year. It was a finalist in the exhibition.

Do you have a go-to camera that you use?

Yeah, the only camera that I've used since I was 18 is a Canon AE1 program. And, then I have a LomoKino. It's more like a toy. It's a camera the Lomography designed a few years ago that you can also use film, 35mm film, but it will give you 144 frames for the film. That one and, well I'm very into the Bolex. I don't use it a lot, but I have a super 8mm. I can't remember the name right now, but I also use that one.

THE PERFECT HUMAN

A FILM BY LILAN YANG

A film remake of Jørgen Leth's The Perfect Human with moving images generated with machine learning, which was later transformed into analog form, reexamining and questioning the contested notion of perfect human.

Tell us about your background as an artist. When did you first start working with film?

My route to growing as an artist was quite circuitous. While I was studying computer engineering at University of Illinois at Urbana-Champaign, I was interested in how data tells stories as an artistic medium and how patterns reveal new findings. But besides it all, I have always been a cinephile and traveler and seen my surrounding world through places and cinema, as I try to understand things elsewhere and out of reach. My artistic research has always been about the myth of cities and landscapes, and how moving images and artificial intelligence might change people's perceptions of places.

My first exposure to 16mm film was during my master studies at Rhode Island School of Design. I enrolled in the Digital + Media program but I did take a lot of analog film classes from the Film / Animation / Video Department - that's where I learned how to operate a Bolex camera, how to run 16mm projectors and how to edit with Steenbeck. I was lucky enough to use all the equipment while having the luxury of time and space to experiment with film as my choice of medium beyond my digital practices.

Tell us about the choice to use The Perfect Human as the substrate for your film.

Because of my interest in the magic of open roads, one of my professors at RISD recommended 66 Scenes from America (1982,) a documentary by Jørgen Leth that includes famous Andy Warhol eating a whopper burger scene. Then I discovered Leth's other works, and the black and white cult classic The Perfect Human (1968) absolutely caught my eyes. The original work takes a pseudo-scientific approach to examine a middle-class Danish couple performing everyday rituals as if they are subjects in a zoo. There are so many versions of remakes not only by many other filmmakers but also Leth himself, challenged by Lars von Trier in The Five Obstructions (2003.) The original film and remakes raised many simple yet philosophical questions regarding this idea of perfect humans. Now my remake with machine learning is an attempt to answer some of these questions in the modern days.

The Perfect Human combines computer generated images and analog film. What was that process like?

I had already been experimenting with generative adversarial networks (GAN) before starting on this project. I applied machine learning processes based on the original Perfect Human film, trained my StyleGAN2 model, a generative adversarial network introduced by NVIDIA, and used my own model to generate fake images. With 23,520 frames in total, I managed to remap the computer's perspective of human behaviors in conversations with Leth's take on the portrait of a non-existent perfect human.

Looking at the previews of the generated outcome in the grid, I cannot help but think about how the placement of images resembles the film strip, and each frame is isolated yet interconnected. Since the GAN stills remain dream-like and film-like qualities, I started looking into ways of transferring computer-generated contents onto analog forms with digital fabrication tools, by testing different transparency materials, printers and laser cutters.

The process of crafting and making is filled with human errors despite the use of digital technologies. The parameters in machine learning, the dpi values from printers and file setups, and the millimeters of error margin from laser cutting, vary the results - Nothing is perfect.

Tell us about the choice to make this film a video installation.

One of the iterations is a video installation composed of a digital transfer of the film and filmstrips on a lightbox. I think about the physicality of film - it makes time

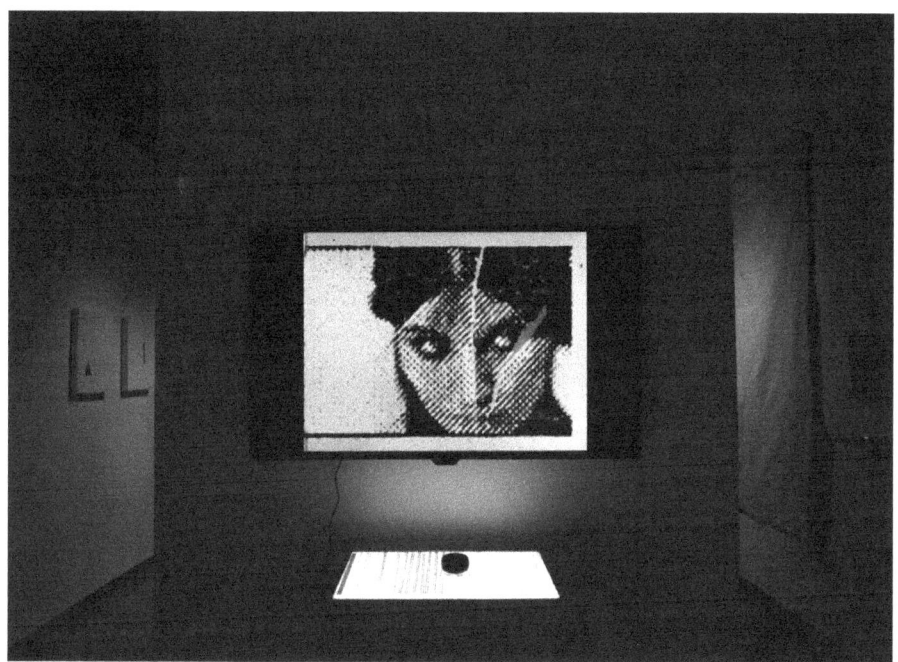

become something we can touch and makes sound something we can see. And there's also a whole cycle of digital-to-analog converting process that might be easily lost if it's only shown in a digital realm.

What do you hope audiences walk away with after viewing The Perfect Human?

The uncanniness. This process of computer-generated images and digital-to-analog conversion is challenging the authentication of a way of seeing. I want the audiences to question what they see. Does film really capture reality? Or is 16mm project-able content really celluloid film?

What's your favorite filmmaking tool?

Film cameras. Even though some of my processes don't involve cameras, the magic happens when I see things through the viewfinders. That joy is always unparalleled.

What's next for you?

I'm enjoying some down time since I recently finished my master thesis, Everything Comes Full Circle, which applies a similar method on a road trip in Texas and California last year about remembrance and forgetting. Part of me does want to jump back into filmmaking and experiment more with optical soundtracks on film.

King Presley

16mm magical realism documentary by Giovanni Tortorici

Tell us about your background as a filmmaker. When did you first start working with film?

My background is mainly in narrative and documentary work. I started working with film in college. There was a cannibal romance short that I wanted to get off the ground, and 16mm film sounded like a really fun format to play with. The hope was to get the textures of skin to make anyone get hungry for people. I think we were able to turn a few folks into hopeless romantic cannibals all thanks to Kodak.

King Elvis takes a unique abstract approach to documentary filmmaking. Can you tell us a bit more about this process and how you shot it?

For sure! We started with a sit down interview with Tim the King. He came dressed in the clothes Elvis would wear to his rehearsals. Ronen (DP) and I talked with him for upwards of an hour. We knew that we would be able to cut it into V.O. if we wanted, and on top of that, it helped us zoom in on the themes we were looking to explore. We sent it to our composer, Deeb, and we hit the studios with him to work on the music. By the time our shoot day came, we had an idea of where the music and V.O. would take us.

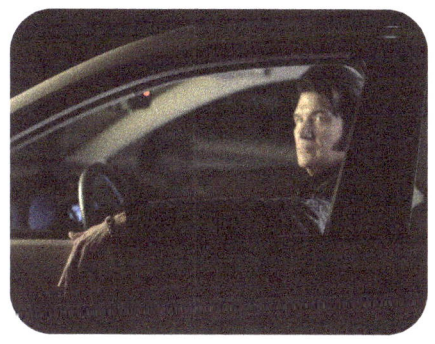

We were filming at a wedding, so we knew we had limited time to get the King's performances. I mapped out the film in a three act structure that we

would shoot in order: (1) Elvis getting ready pre-show, (2) The performance, picking up speed and intensity, (3) The performer's high as he sits in the car. Ronen knew what to get, so we ran around and scooped up the shots.

For the cannibal film I did, I rehearsed with the actors like it was a stage play. It yielded some great performances, but there were times I clung too close to the security that rehearsal gave. With this, I wanted to go in a completely different direction. It was an exhilarating shooting experience. We had conversations and storyboards for a solid idea of what we were getting. But by the time we were on the floor, without a video tap, it was a spontaneous Olympic pool of the unknown that we jumped in together.

How did you meet Tim Ritzka, the subject of this film? How did you pitch the idea of King Presley to him?

We found him on a tribute artist website that looks like Hinge for celebrity impersonators. After checking his profile, we went ahead and emailed him. He hit us back and I had a call with him early on where I talked about how I was interested in the performance aspect of what he does, and where the performance ends and identity begins. We bonded over my past in theater and his love of performing, and the call ended with him hopping on the project.

Any advice for other filmmakers looking to make documentaries on celluloid?

Prepare! The conversations you're having with your team become even more important by the time you're in the field. Especially if you're on a budget like we were. Really developing those questions we were exploring, getting the composition before we shot, and storyboarding all went into shaping how we shot it in the moment.

Do you have a favorite camera, film stock, or tool for creating work on analog media?

I don't. Whatever fits the story we're telling becomes my favorite. I want to use the tool to push the boundaries of the story we're telling. If the analog film tools can start bringing a realm of subtext to the film that wasn't there before, that's when I know it's a fit for the project. And of course, a lot of times, the tools and cameras we use are dependent on the given resources we have to shoot with.

What's next for you?

I'm developing a proof of concept short that we'll be filming on a Texas ranch. It's a Southern gothic horror movie about a monster named Bone Man. We'll be filming on 16mm and I can't wait to be back in the horror realm with analog!

Anything else to add?

Hire Tim Ritzka for your parties!

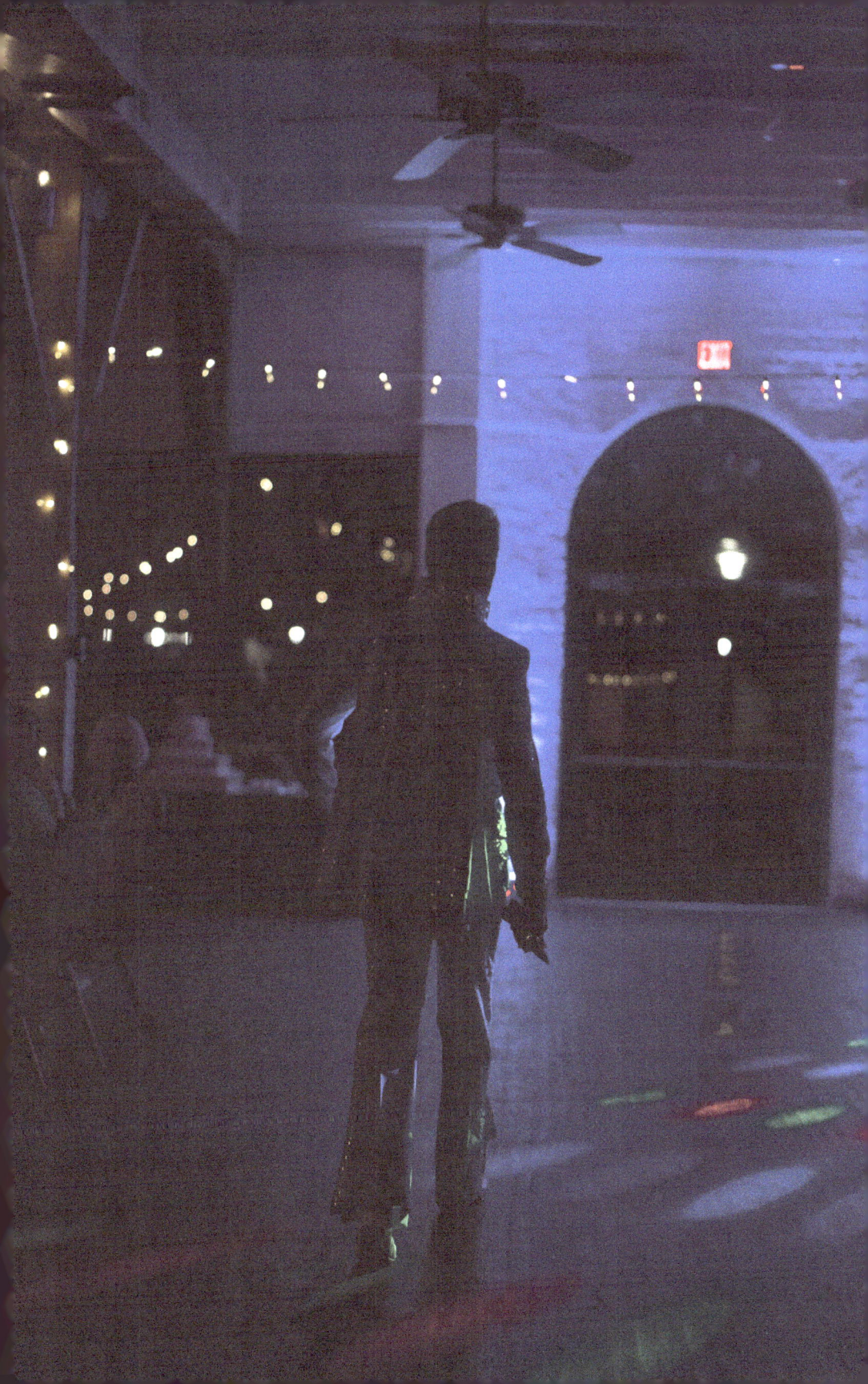

Gabriel D. Evaristo
The Samsara I Saw

When did you first start shooting on film?

I started shooting on film this year, this movie is the first one I shot.

Tell us a little bit about the Samsara I Saw. What inspired this piece?

My first idea was to make a scratch film, but I was afraid that this would be too little, so I chose to record some of my old paintings to use as an underlying theme for the movie. I took inspiration from some scratch films I found on youtube.

This film has such stunning hand-drawn animations and scratches in the film. Tell us about this process.

I am an animator first and foremost so I really wanted to find out what kind of animations I could do in the space of a 16mm frame. It was a real technical challenge, so I found an interesting solution to the

animation process. I used a light table to illuminate the film from behind and I used a tripod with my phone to magnify the frame with the camera app, this way I could see the frame more clearly. The process felt like drawing using a wacom tablet, because I wasn't looking directly at the frame. I also had the chance to try out some paints and pens and ended up using a voltmeter probe dabbed in bleach to make some of the scratches and bleach as paint in some parts, it was awesome to see how the film reacted to these processes.

Tell us about screening at Pan-cinema Experimental! How was the experience of watching your film screen to an audience of experimental film enthusiasts?

The film was developed in a lab that took place as part of the Festival's programme, so the other filmmakers and I knew that our films would be screened and this made the whole process really exciting from the beginning. It was kind of a dice roll because I had an idea how things were gonna look like, but the screened version was really different, it was really cool. Unfortunately I didn't have time to put more elements on the film that I would have liked, but the thing is I can always return to the film and scratch it some more. The screening was really cool, I was nervous but it was cool to see the reaction of the people to the scene with the lightning crash.

What do you see as the biggest challenge with analog filmmaking?

Having a camera and film are really challenging, at least here in Brasil, they're really expensive. The process of revealing the film is really hard as well, usual processes involve controlled substances and an error in the process could make the film unwatchable.

What do you hope audiences will walk away with after viewing this film?

Curiosity and a sense of awe, the recording is really not the same, but that's what I hope.

What's next for you?

RIght now I am studying animation, but I'm looking forward to making some modifications to this film and scanning it, to add some digital animations as well.

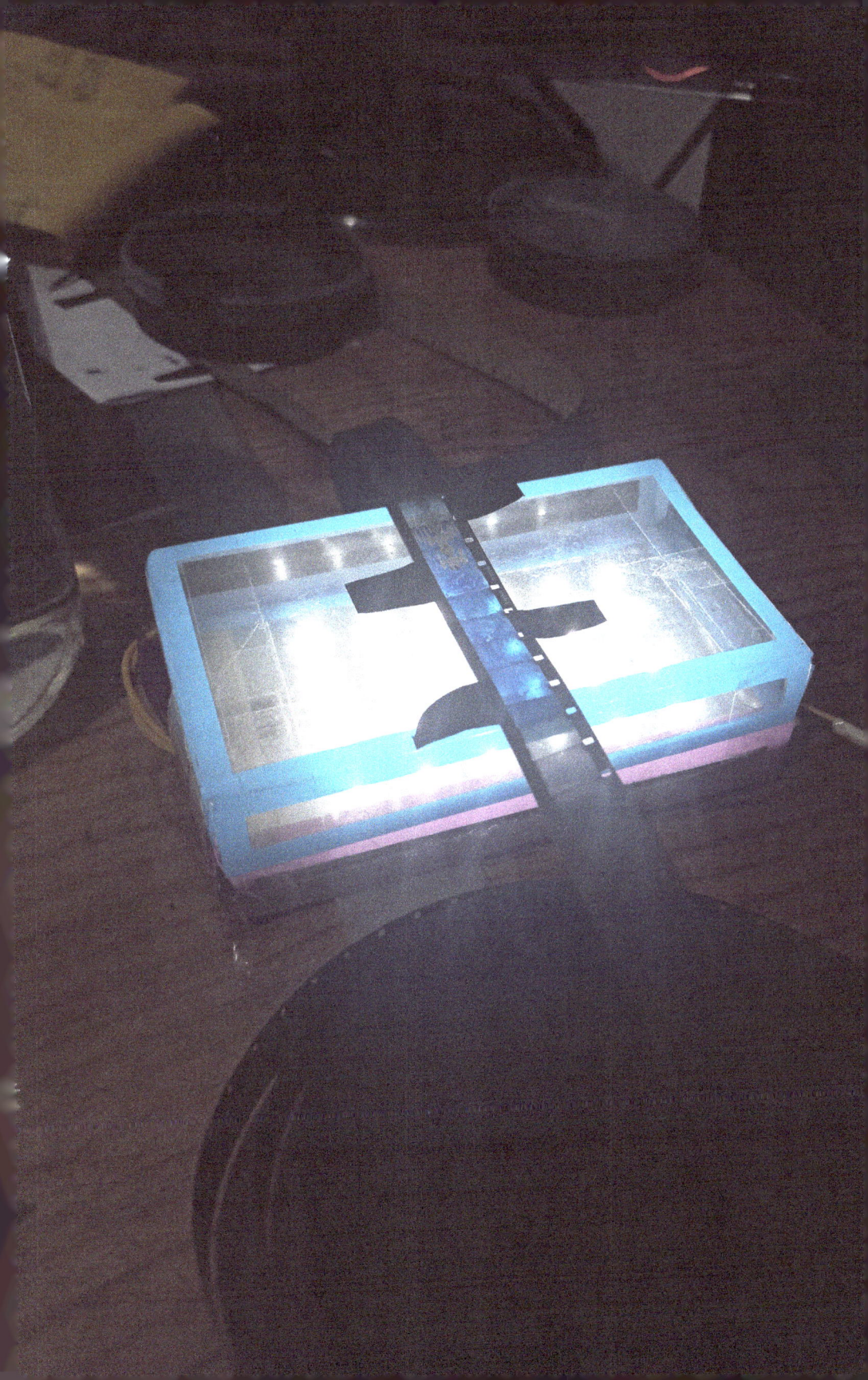

Once

Memorable in the ambiguous weeks following Leland's death was the thanks of a family member at his memorial service, who approached me with gratitude for the amount of photographs that we had taken together. I received them in an envelope. I am twenty-seven, and my 4x6 college graduation prints remained in his room until the day he died, both of us brightly grinning in blue. My designated family seats in the auditorium went to him. It is impossible to convey the strangeness of getting back the catalog of what you have long ago given away. Prints and letters addressed and sent.

Noticeable to me and a source of great emotion were photographs papering the walls of his memorial that he had also taken after our relationship ended. I recognized them by the distinct, individualized traces of the cameras I had given him present in the images. During our friendship and romantic partnership, I gifted Leland no less than three cameras, probably more - a 35mm point and shoot, a Minolta XT-1, and an old Polaroid 600. I would buy film for the both of us. We would walk to the lab from his house to drop off film and buy prints. I always ordered doubles. They populated commemorative arrangements.

Glimpsing the photos that Leland took with the cameras I gave him following our departure allowed me into a feeling of joy for his making, that something which defined our bond as special also designated the specialness in his other lives and creative endeavors. I am in constant pursuit of a greater awareness of who he was in many iterations of himself with others. It was extremely poignant that a practice which developed between the two of us of pointing to significance by spontaneously creating a record was a tool for closeness that he took with him throughout his wide and vivid life. There is no debating the preciousness of film photography. It comes with a certain gravity. This gravity is made visible by the awareness with which people respond to being in front of a lens, in the shared nature of a moment-artifact. How we are still unaware he is dead on the day of my graduation, and I can hold it in my hands.

I spend a lot of time now thinking about memory. I have been making work about grief for three years and feel suddenly in the wake of this great loss that I have attended to nothing. There is a futility and confusion that escapes language surrounding the knowledge that Leland existed and we lived a life together and it will never happen again and I cannot access it, while occupying the

Essay by Ellery Bryan

same body and the same bed and the same car. I cannot step through the threshold. It makes it feel like a trick or a mirage that happened to somebody else. Every aspect of my life has been touched by him in our six years of being with one another, and my life becomes something unrecognizable and confusing to me without him in the world to provide continued context and safety. I cannot grasp onto it. There is a certain obvious but unbearable irreconcilability about the way that he shaped my life and that I cannot bring him with me. It is lost to time, which continues unjustly on. When he died I felt that the only appropriate response to his death would be for the world to stop. It is cruel and unfair to me that it turns without him in it.

David Wojnarowics said in his memoir Close to the Knives, "There is no difference between memory and sight, fantasy and actual vision. Vision is made of subtle fragmented movements of the eye. These fragmented pieces of the world are turned and pressed into memory before they can register in the brain. Fantasized images are actually made up of millions of disjointed observations collected and collated into the forms and textures of thought." A professor in my graduate program would speak often about the split second of processing between stimulus arriving at the eye and comprehension, light tracing the world upon a digital sensor and its subsequent rendered image. Film reacts directly to light in the precise moment of exposure, creating its mirror. The light acts upon the chemistry adhered to its base and it is materially altered into an immediate reflection of that specific arrangement in image, which can only be read after a chemical bath. It is a small miracle to hold a moment still. To affix it to itself.

In May I exhibited the first visual work I had

made since his death in October, composed while sifting through the archive of images which merged his collection and mine. Most moving to me are not our images of each other, where we make portraits of arrested time, but instead, where his motion and gesture become apparent in the objects themselves. Action suspended on a visual plane. There is a photograph that we took on Valentine's day with each of our fingers activating the shutter. It barely depicts either of us, but our fingerprints remain preserved on the backing where we passed it back and forth during development. A record of movement without illustrated complications of change or youth. I became entranced with these aberrations in the same way that I locate myself by his painted tags, which decorate and adorn the city as components of my routine that bear the construction of my life. Borne of the steady and skillful movement of hands bursting into flight, without the vision of his shifting younger self, depicted in a moment before glasses or between tattoos. He is still a direct actor on my visual world. It lets me know where I am.

Below is the exhibition text for What the Transient Hour Brought Once and Only Once:

This exhibition was composed of scanned artifacts, mounted photos and projected film work pertaining to the sudden death of my former partner six months prior. The backs of polaroids we had taken together suspend a tactile record of our fingerprints, formed while the images developed. Scanned and magnified to 42x42 archival inkjet prints, they line the walls, expanding the record of his touch as enigmatic and impenetrable colorfields. They behave as subtley detailed thresholds that part the viewer from accessing sight of him. Each developed photo is mounted side by side in acrylic casing, some facing the viewer and some flipped, such that fragments of the original materials are present for inspection. Every aspect acknowledges that there is a side withholding. The prints tower across the edges of the room, inverting cathedral windows.

Following Leland's death in October, I inherited a number of letters and photographs I had given to him throughout the course of our relationship - it was a disorienting experience, of gifts I had parted with and forgotten returned to me. During our years of friendship and romantic partnership, I gave Leland three cameras. He was an artist, and our collaborations were informal and intimate. Making things together was the vernacular of our interactions, without explicit structure. He was my primary subject on the first roll of film I ever shot as a teenager. We continued to depict one another back and forth over time. His many gifts to me were carefully constructed by hand.

I have many pictures and visions of Leland, we spent a formative span of time involved with one another. My index of him is expansive. When sifting through this catalog of images and returning to the home we shared in Baltimore, my most profound obsession was not with his pictures but with things that he touched, lacking the same reference to his appearance frozen in time, and as though he could have just immediately left them moments before my arrival. Tactile traces of my partner influence the structural and visual experience of my day-to-day life. Buildings and bridges he tagged guide me to work and back home. These remnants don't require mediation through memory. They are living artifacts in a world which he still acts upon while I navigate it in his absence.

Scanning the photographs he had saved of

us, my most beloved discoveries were in labels he wrote by hand and fingerprints suspended on the surface of a rapidly developing photograph that we passed between one another as the chemistry settled into a rendered image. He stands behind the camera and looks at me.

Leland and I collaborated on many things and the most creative one was our love of each other and the safety carefully constructed within our insular world. It was a joy to celebrate it in artwork and curiosity. I have always been bashful about taking a picture, he never was. It seemed that particular kind of making lacked the self-conscious reflexiveness to him that it held for me. It was a direct tool of rendering. The space for chance was just play. In the months following his death, I shot more film than I had since we started together. I stopped planning ahead and allowed myself to be taken by the act of photography, where my only thought as I looked into the viewfinder was about what was in front of me. I have always tried to lean into the uncertainty inherent to the many interventions between capture and developed image in filmmaking and photography as a generative mine for expanding intuition, and positive reinforcement for belief. I made a film for us in a day on Christmas, performing with myself in double exposure across a split screen and imagining myself on both sides of an absence. Anne Carson says that memory is bringing the absent into the present by drawing attention to its "lostness." The image mediates an echo. I reside in its cavern.

I am tethered to this loss which acts upon every subsequent experience I inhabit by holding it in opposition to vacancy. My relationship with Leland guides and transforms me. When somebody leaves their life everything they held becomes a precious quantity, and you reckon with their abrupt stance in time. They hold the moment still. There is no sense to make of it but to insist that it happened and to bring it with you. He touched the many things in my life and they changed. I am one of those mirrors.

that I have

broken into two

Ellery Bryan

What inspired that *I have broken into two*?

that I have broken into two was created in response to the sudden death of my former long-term partner Leland, two months after his passing. Alone for the holidays and in a kind of outpouring of grief, I made the film in an attempt to address and bypass the veil between us by placing the dislocated image of myself on either side of it, hands reaching toward one another, allowing an interaction to occur without the possibility of seeing or meeting. It was a performance about trying to reach him using my body as the site and symbol. I tried to take agency over the veil, of which I am completely powerless in my real life, by holding it over my body and rendering it behind its screen in development. When I perform on film, an image of myself enters the world of apparitions. I can never meet him, but I can construct a visual world where I can put myself as close to him as possible.

The visuals here are so captivating. Tell us about your process making these visuals.

I shot this film on Tri-X B&W positive film and double-exposed each split shot, dividing my performance across each half of the frame and watching the footage counter to backwind. In order to create the visual image of a rupture between two worlds, I half-processed the film in my basement using clear tape as a resist against the chemistry down one half of the film strip. This method physically withheld the reversal bleach from the tape-covered partition so that one side of the image is developed as a negative, and the other as a positive. I think about the colloquial presentation of ghosts as shades, light in the darkness, in contrast to the living whose forms are defined by shadows. In all of my performances I am trying to use the image of my body to confront and manifest visually what I have no control over, and what cannot be seen. I cannot reckon with the divide between myself and somebody who has died physically, so I perform the metaphor. I am drawn to use film because I can intervene with the image, and because the medium allows me to align form and method with content - because film cannot be reviewed, I cannot see my own performance.

When I film myself, I am surrendering the results, unable to perfectly frame or direct or time my visuals. I ask for help in the form of intuition and prayer and frame it as a kind of ritual action, positioning myself behind a different kind of veil, a memory made of light. When it works I say thank you to the invisible directors I am making the work about and think of their gaze and expertise as an active agent in the process, guiding the split-second decisions I have learned to trust over time. This film was improvised through that learned intuition.

You often make work processing grief and memory. How does it feel when you complete a film drawing from these themes?

Completion can be tricky because it can feel like leaving behind a tether to the person I have lost, like our work together was knit into my day-to-day in a way that makes me think of them and reference them constantly, and when that process of devotion and awareness draws to a finish there's a moment of fear that I'm leaving them behind or won't get it back. It can be like its own little loss, that phase of my life and my grieving is over. I start to feel worried about when I will start making work that isn't about them because it feels like a relinquishing to move forward without somebody who has died, and to devote your time to the stream of your life. But I look for them everywhere, they inform everything that I make. My film practice is a way of maintaining a relationship to them by relying on ephemeral guidance toward what is important to capture and how, pulling on inspiration from their lives and our overlapping visual languages. Making anything is a form of interdependence and keeping in touch, and a practiced act of noticing and building a mutual understanding of signs and significance. I will always be reckoning with time, which creates constant ongoing distance from our life together while slowly building a new and different one.

Any happy accidents or surprises when making this film?

Everything about this film was a totally unexpected delight. I had never half-processed before, have had many self-filming failures, was totally new to almost everything about this project and didn't really expect it to work. It was completely unplanned, I only happened to have enough chemistry at home left-over from grad school to make it, I had the idea and made it same-day in one shot. Kathryn Ramey's book gave me the recipe. My expectations were utterly low and so it felt like the spectacular results were totally beyond my own doing.

What do you hope your audience walks away with after viewing I have broken into two?

With all of my work I hope that the audience has an emotional-sensory response to the piece. There's no narrative and no perfect takeaway. For me it's a meditation on grief and my hope is for people to be moved by that grappling into a kind of reverence.

What inspires you to keep making work?

Making work is the action that feels the best to me in my brain and body. It

makes me feel usefully whole and allows me to devote myself to attentiveness, meaning and beauty. Most things after a loss feel devoid of enjoyment and their former significance. Making things is a physical action toward beauty, intuition and enjoyment - it allows me to be present, hopeful, to notice, to look forward to things, to feel a connection between myself and things outside of me. Sometimes other people meet me in the grief, and I get to experience the shared joy of their own relation to the feeling, and their own meaning and vision. It is all for my community within which these losses have occurred. It is a way for us to meet over them and observe their gravity by the amount of resources and care allocated to illustrating their memory and maintaining their presence in our lives.

What's next for you?

This summer I've been taking a big break! My workflow has changed a lot to a shift toward still images, which are spontaneous and the equipment is easier on my body while still allowing me into that feeling of actionably being present. I'm about to teach a lot in the fall and I've been asking myself what success looks like for me right now. So much of my life and emotional world this past year has been so private. It has made me ask myself what feels right about my career. I want my work to reach my closest community first followed by the group of people who emotionally resonate with its purpose, which doesn't necessarily mean trying to get into a bunch of shows run by strangers. I'm not sure when my next production will be, the many hours of footage that had been building toward something immediately before Leland's death have been put on an indefinite hold.

I'm wondering whether I'll find a way for them to exist as they are or if they're worth returning to, when my world feels so utterly different. I would like to rest and to move toward ways to share my work that feel rooted in reverence and connection, and to leave the rest. I would like to feel closeness to my loved ones and identify what makes me feel enjoyment and magic in my life. That used to be more focused on work and stability - it's not so much anymore. It's very personal and emotional, and about feeling whole and grounded.

The small opening I held for the work I've made since Leland's death was extremely intentional and the attendance was limited. What I wanted most was to create a physical temple to this person and this great loss and put all of my closest friends in it to celebrate it and feel its resonance, and I did. I have been very careful about where this work has existed, how much pressure I put on it to be resolved, how I present it in the world. I have so much respect and love for Analog Cookbook, which has given me so much detailed information about how to make things, so much inspiration, such a feeling of collective care put into each of these publications toward a persistent artform, lowering barriers to access in a difficult and expensive craft fighting in a technical age against obsolescence. I am so grateful for this publication as a landing place for this slow and still developing tender work.

Anything else to add?

Nothing but my gratitude.

Sun Coming and Casting a Shadow

A film about time, memory, fear, and the challenges of holding onto joy.

Film by Daniel Robin

Tell us about your filmmaking practice and style.

When I was a kid, I grew up in a small town in Bakersfield, California, and I just didn't really have a lot of exposure to art, so I really didn't know where to put this energy that I felt. I was a punk rock kid, I played the bass in a punk rock band, but that didn't really play anywhere. And I listened to a lot of music. It was when I took this class in a community college in Bakersfield, and I saw one of Orson Welles' earlier films. Maybe it was The Magnificent Ambersons. I was just blown away, and I start thinking about, "Wow, filmmaking. That would be really interesting."

I got into this really exceptional, somewhat elitist undergraduate program at San Francisco State University, and we had access to all the 16mm camera gear getting into the program allowed you to have. I made my first film and it got into Sundance. That was huge. I didn't even know. I went snowboarding at one of my screenings and got yelled at my programmer, because I didn't know. But it was the professors who came up to me. They were moved. I could tell. I'd never had that kind of experience of something that I made, that I did that I shared with the world. And with each forthcoming film, whenever I have a similar experience, I feel like I have a sense of purpose, and it feels grounded in something real and substantial.

Two university professors, one working in Georgia, the other in Virginia...

...given an uncertain window of time to share our lives together.

And George (Eliot), the cat.

In terms of my style, that first film I made was about my roommate. He also grew up in Bakersfield, and we were punk rockers in high school, and he and his girlfriend moved to San Francisco the same time I did. We got this little house together. He and his girlfriend were also becoming pretty big junkies. And you get exposed in high school and university to drugs, but heroin? I was like, "Whoa." And they were really getting into it, and I really cared about him, so I had talked to him about making a film about his relationship. The majority of my fellow classmates were pitching, and making fiction, or really conventional documentaries. For this film, I did optical printing, and I shot in black and white reversal. I felt like "All right, this is how I can make an honest and emotionally honest film," --if I make films about my life experiences, my family members, relationships, me. I've always pursued films that revolve around my life in some capacity.

I think form and style follows content, at least for me. And that's how I teach. You have an idea. Each film idea dictates its formal style, its formal approach. And I do gravitate towards film because it was my first foray in the filmmaking in terms of celluloid.

Sun Coming and Casting a Shadow is so joyful and somber at the same time, which I think is so beautifully reflected in the

title. And I would love to hear how you went about striking that balance between the two feelings.**

A lot of my choices in terms of tone, just really come from my experience. Shadows on a literal meaning, they do bring joy, and shadows can be visually mesmerizing, but shadows can also have this kind of a dark connotation. I think really, there are several themes running through this film. I have these themes that I'm obsessed with and I'm like, "How can I fit all these things I'm obsessing over into this little film?" Part of this balance is I wanted to express is the emotional complexity of joy of this relationship and having Jenny and George in my life. It was so joyous during this incredibly troubling, uncertain time of the pandemic.

There was also the layer of the inevitable, that Jenny was always going to leave. She came here because she's an academic in Virginia, and she got this really competitive fellowship. So, she got to come here for a year, and that was the year before the pandemic. And then, the pandemic allowed us to be together for another two years. And so, there was always that anticipation of this inevitable separation, and it was haunting me, and yet, there was the joy of sharing our lives together.

Formally, for the first half of the film you use text, and then you go to voice-over narration.

Part of that choice for text is I'd rather not use my voice. And if I use text sparingly, it insists that I write with great economy. The voiceover isn't an all-encompassing because I really want to have balance between how much is used--whether it's text, voiceover, or sound, whether it's minimalistic, and letting film space really express ideas and emotions.

The voiceover was a letter. It was a way for me to express further ideas and build the narrative, and evolve. I guess I want to say emotional work. That was the mechanism, the formal mechanism, was this letter.

The point where it switches from text to voiceover is so telling of the other side of this love story. It's like, we're on the other side of nostalgia. At one point you say, "Nostalgia is dangerous." I think anyone who's ever been in love or been through something knows you can get in that space of romanticizing an experience. I would love to know more about that idea of nostalgia being dangerous.

I really appreciate that it resonated. It's something I obsess over, or think about. A lot of my films revolve around memory, and how memory functions, not in a scientific way, typically, but more in an emotional and spiritual way. And this idea of longing for experiences, or things that you've experienced, or feelings, or emotions that have gone, and there's no way of ever experiencing those same things again. You can have maybe a modicum, or a similar experience, but those long mornings, like how I ended the film, you can't experience again. And the danger, I think, is getting trapped in that space, that emotional space, for longing for something that is unattainable. And I

think that, to some degree stagnates your growth as a person. If you don't experience whether it's grief or sadness, and you just keep going back to this longing, that's the danger.

There's so much about the fear of being alone in the pandemic. And I love that you have this cat, George, because I think we talk about that with pets.

George is Jenny's pet, so when Jenny goes, George goes, but this idea of fear of being alone. So, there's a literal fear of being alone, and not sharing that life with Jenny and George. George is, as the Jews say, part of the mishpachah. Mishpachah is Yiddish for family. So, there is that, but it goes beyond the literal, and more of that spiritual sense of being alone in the world, just even as a filmmaker, or as a person moving through the world. Even when you're in a relationship, or you're amongst family, or great friends. At least how I experience it, I always feel alone. I just do, even in physical proximity to people. But when I do have Jenny and George in my life, and it brings that joy, it's I guess maybe distracting me from that loneliness a little bit, but I think there's that ever present hovering sense of being alone in the world.

What are your go-to cameras and film stocks that you like to use?

When I got into the Undergraduate program at SFSU, one of my classmates, Sandra Nettelbeck had a super 8mm Beaulieu camera. Ever since then, I've fetishized that camera. And this idea of fetishizing cameras, I know that probably isn't such a great word to use, but I was really enamored with cameras. When I got introduced to 16mm cameras, I was like... We had CP-16s, like those news cameras. We had Arri S cameras which I really liked.

But then, my second year in the program, I bought my own Éclair ACL And it has these little 200 foot magazines. And then I upgraded and got a couple 400-foot magazines, and shot some features and I haven't used it in a while. My next film I want to shoot with the ACL. I always wanted an Aaton. Those were like for me, the coveted one, but eight years ago I was able to get a Beaulieu, and I shot a film with it.

Do you have any favorite film stocks that you like to shoot on?

I still have a bunch of Super 8, and that was one of the how I came to Sun Coming Out and Casting a Shadow. I had intended to make this other film that I wanted shoot on 16mm, but the pandemic came, and it's a bigger film. So then, I had all this film stock, and I knew I was going to be in my home. And I've been living in my house for many years, and I knew I always

wanted to shoot the shadows, and I just didn't have a narrative or context. So I just went to school all masked, and just brought a boatload of film stock home, and it's all pretty much 200 Vision 3 stock.

I was shooting on 200 ASA, and I'd use an 85 filter, color correction filter, because I didn't do didn't want to deal with that in post. So, I wasn't getting a lot of latitude, and I had a bunch of 500 ASA rated, and I should have shot with that, but I was just like, "It's going to grainy. It's going to look shitty. I know, just shoot the 200 ASA," so I did that, and, oh well. What are you going to do?

And I think it looks great though. I think even with the more grainy parts of the film, it still looks amazing.

Yeah. No, I like grain. Grain for me creates that visceral, palpable experience.

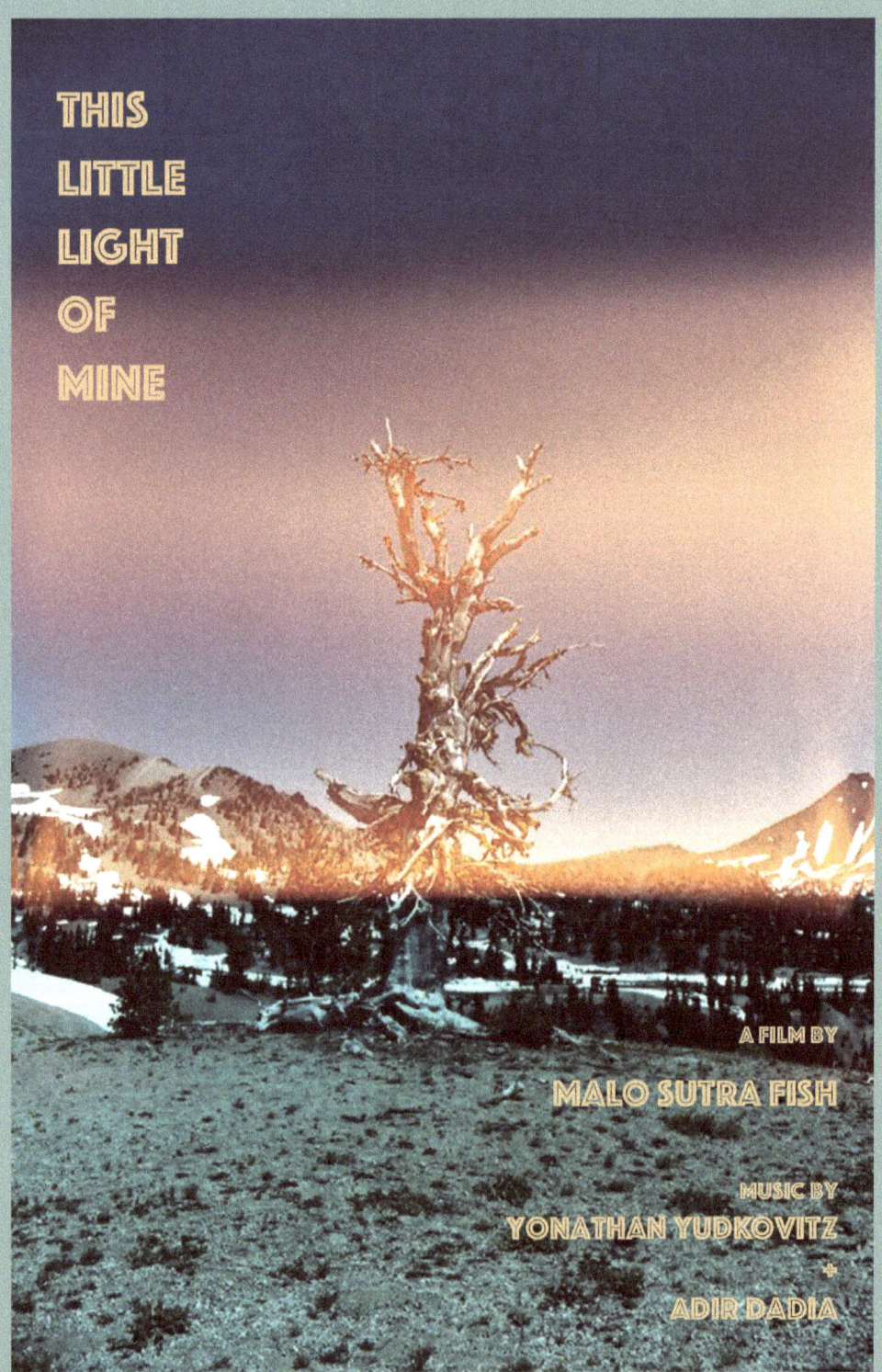

A short film
& essay
on photosensitive
epilepsy
by Malo Sutra Fish

Why is Experimental Cinema the best way to talk about epilepsy?

Epilepsy is a condition that most people know about from horror or sci-fi films perhaps; The Shining and The Exorcist being the best examples, along with the many uses in medical soaps. Convulsions, near death experiences, the gore, the foaming at the mouth, the mystification of evil possession or the "craziness", the flickering effects, there are so many reasons to use it cinematographically to express horror and provoke panicking. Yet, how many people know about this very diverse condition? How many people know that a wide range of seizure exists from absence to temporal seizures to generalized seizures; that photosensitive epilepsy only affects 3% of the epileptic population, which in my case started when I was six years old and is a lifelong condition? Documentaries can try to portray the daily life of epileptics. Yet, how to convey the experience of a seizure itself? How to cinematically express the internal turmoil without the common traps that are bore, gore or self-pity? As most readers of Analog Cookbook know, experimental cinema is first and foremost an extremely varied genre meant to experiment with the material itself – film, light, capturing, media, sound, editing – in order to provoke a sensational dialogue with the audience, have them experience the film not only intellectually but with all their senses, their emotions, their conscious and subconscious. In a nutshell, Experimental cinema is all about the meta.

As a filmmaker, studying the meta of cinema has always been at the core of my work, may it be the meta of cinema physics, the meta of photography, the meta of writing, the meta of sound, the meta of editing. You all know about these obsessions, as they are common to all of us. Yet, as a photosensitive epileptic, not only does my work finds obvious limitations due to restrictions from the condition itself (hypersensitivity to light) but as well as the industry's extremely demanding expectations make it very hard for me to get started professionally. However, at the same time that condition offers a silver lining when one manages to overcome these very restrictions: an acute and almost innate understanding of light, of image sequencing, of rhythm; all the ingredients making experimental art the perfect medium, allowing a space for epileptic filmmakers to express themselves. That

paradox of having both the trigger and the antidote can be found in Structural film. That's what got me hooked to experimental cinema. Luckily my seizures are controlled by medication and polarized sunglasses, allowing me to enjoy such films– not that I can binge either. Going in details about what I can and cannot watch would need another essay of its own with video extracts to support my words. All that matters is to know that static flickers are not my worst enemy, camera and light movements are. A circular traveling in a crowded casino or a traveling view of a moving car with the landscape scrolling by the side window will give me a stronger headache so to speak than a pure minimalist static flicker film. Speaking of which, a fine jewel of the genre is Alexandre Alagôa's "The Grid" (2021), recently presented and award winner at Experimental Film East Anglia for Best International Film and Best Editing. Another contemporary filmmaker whose work I appreciate greatly is Arc from the Black Hole Cinema collective lab in Oakland, CA. What those filmmakers and the more historical figures of Structuralism have in common is their ability to target without necessarily knowing it what it feels like to experience epilepsy or photosensitive epilepsy. Stan Brakhage's work hit me at the tender age of seventeen like a revelation initiating the genesis of "This Little Light Of Mine" (2020). I could try to put into words the strangeness of a photosensitive aura, this conscious feeling of your brain breaking down mixed with all the abstract visions of reality folding upon itself. I could try to evoke in this essay the extreme eeriness and worn out feeling of waking up from a stage 3 coma induced by my body to prevent any more damages from the convulsions. But words simply do not convey, they lose meaning, it all gets lost in translation, lost in what you hear (and fear) and do not (cannot)

grasp. Structuralism film is a genre that forces a sensory experience unto the audience, playing with their brain and how it captures and treats light and sound. Thus, without it being its main attempt, it actually portrays best what could possibly be felt by someone with my condition undergoing a generalized seizure.

It is the matching language; when words lack, finding the image always works out. With my film, I wanted to get down to the meta of my condition using the meta grammar of the art form.

However, Structuralism was not the only main influence, which is not that prominent in my film. The reason being I wanted to reach out to people and specifically to fellow epileptics, send a message in a bottle. Another important ingredient and essential message was poetry and the fact that we - epileptics - need to live with this. Living with it means accepting it, overcoming it, finding the silver lining, finding the strange beauty emanating from the imperfections, from the visual impairment, the absurd poetry from the dysfunctional connections;

a coping mechanism to not completely dissolve in self loathing without falling into a weirdo's fetish either. Epileptics are tight-rope walkers always in search of balance, always having to monitor themselves both physically and mentally, always unsure about what they can reveal to others, so afraid of the others' projections of fear onto them, walking the line above the abyssal endless pit of invisible neurological disability. Sally Walker-Hudecki's latest film "Foreign Ages" (2022) about her experience with temporal epilepsy is very telling of this tight rope approach, and I was fortunate to meet her through the 8Fest selection process as she was a member of the directors' committee. A sister in filmmaking.

I wanted to shine a soothing light. And that's where Expressionism came into play. Maya Deren's non-technical approach to film, the poetic expressionism of her work was a huge influence in my process to grab a camera and shoot with my guts, holding the camera by my rib cage or at arm's length and not constantly using the camera's viewer as that really affects my brain. Go with the flow, with the moment, embrace improvisation. As much as I knew I wanted specific shots, specific areas, I also shot riding my bicycle, I shot in the forest, in parks, in streets, in a cinema, as a passenger on a much awaited road trip to the desert. A Wabi-Sabi mind set to enhance and beautify all at once the imperfections of my approach, my condition, the camera's scratched lens (the reason why that little Elmo had been disregarded before I took a hold of it), this was a constant of this film's process. Super 8 Ektachrome is the cinematographic means to express memory and our intimate capturing made by our brain. It is the imagery of souvenirs. Memory works like Chris Maker's "La Jetée" (1962), a sequencing of photographs that may find fleeting movements through emotions. Super 8 had to be my film's format and expressionism its main characteristic.

This film took me 18 years to make. This time is revealing of financial difficulties as well as lacking the ability to drive, the lack of freedom of movement. It also reveals the doubts I faced as a filmmaker when a lot of my peers projected doubts as far as my abilities to be a filmmaker as a photosensitive epileptic. For 4 years I didn't/couldn't touch my film. I wanted a true work on sound. And my doubts prevented me from asking Yonatan Yudkowitz – a professional musician - to work on the soundtrack as I felt illegitimate to ask for his time. Turns out he said yes on the spot and made the best soundtrack I could dream of, within a matter of 3 months. That gave the strength to get back on the saddle, kick the doubts and smirks away and believe in myself. The feedbacks I've had thus far, especially from Japanese filmmaker Isao Yamada – a fantastic experimental expressionist - now a collaborator, from

fellow filmmakers, from people like Beth Gibbons, from Sally, from friends, from people in festivals' audiences, all this gave me the strength to overcome fear, doubts and affirm myself as filmmaker, become part of a collective lab (L'Etna), learn to process my films and keep on trucking.

My journey making this film is marked by time and space, which strangely enough is the subject of my film as a seizure cuts you from time and space in addition to yourself. Time was both a struggle and a blessing. Taking my time made space ever so giving, specifically in my first home in Portland, Or, where in the basement waited for me a box left by a previous owner filled with ophthalmic slides – pictures of eyes. It gave me time to avoid traps. It offered me the needed reflection to make this a film first and foremost. It gave me the most inner knowledge of myself, the everlasting assurance that I want to be a filmmaker and am one, and that experimental art will always be a part of my process, no matter how much I strive to make all sorts of films. Life itself is experimentation.

Best words given to me by Isao Yamada:
"Never pay attention to what
they say, do your thing, always."
Let your light shine.

Much love to you all,

Malo Sutra Fish
(July 21st 2022)

Movement and Potential in analog futures
- Ciccio Coppola

Walter Benjamin, evolution of technologies, past nostalgia for present anxieties, the digital and analog dichotomy. We've heard it all a million times. The trope is as tired in experimental film circles as Boris Johnson is to British politics. How then to breathe new life into the topic? Movement and potential, concepts taken from the psychoanalytic field of affect theory, offer new scope to the field of digital to analog experimentation.

'Affect' refers to the biologically pre-programmed reactions humans have toward the intensity of new information. A wholly separate occurrence to a conscious emotional reaction. Silvan Tomkins developed this idea through close observation of infants in 1955, finding expressions of shame at a period before the infant could have any emotional concept of prohibition.[1] The delineation between affect and emotion not only occurs as we grow into self-aware beings, but also temporally in the moment. There is an observable split-second delay between receiving information (affect – the intensity of an image) and being aware to exert will upon it (emotion – subjective content). This gap in time is understood by social theorist Brian Massumi as an 'additive space' between impression and emotion. The 'additive space' allows for an accumulation of relative perspectives and the passages between them: movement and potential. Movement in the passages between the relative perspectives and potential within the unlimited perceptions that the space enlivens. Intuitively, it resounds with our experience of never resting entirely still, as too the world around us is unstill. Our eye continuously collects multiple visual impressions, and our brain transforms them simultaneously into perception. Additionally, the anticipation in-between visual impressions, extends the actual moment beyond itself, superimposing one moment on to the next.

Cross digital and analog experimentation breeds fertile ground when we apply the concepts of movement and potential. Going by definitions - Digital is associated with discrete on/off units, while analog can be defined by quantifiable and continuously variable units. Yet the distinction between the two is not so clear-cut.[2] Digital is inherently visual, and screen based. Even, if it is made by numbers/algorithms it needs hardware on which it can be processed. Moreover, when

1 Sedgwick et al., Touching Feeling. p 93
2 "Shaky Distinctions.", p 14

Figure 11: Picnic – Paul Vester [6]

it comes to images, films, and our perception, the digital must connect with the realm of senses. And this is, of course, materially processed through our body and mind. Taking the example of digital sound; [3] it is only the coding of the sound that is digital. The digital is sandwiched between an analog disappearance of the code and an analog appearance out of code at the listening end. We can think of them as working together - Cooperation of digital and analog in self-varying continuity.

The digital input can be seen as a derivative of the analog. Yet digital and analog imagery carry different historical expectations and associations. Analog Film reels are made of gelatin film and over time there is a chemically encoded process of entropy. The material decay marks analog film as a historical document. Artist Edd Carr iterates the feelings of physical loss situated in the past. In his public survey on the mental associations with analog film images;[4] the overwhelming answer was of a 'nostalgia for the past'. On the other hand, digital cinema lacks the same material association. The digital image is instead linked to ideas of the "Poor Image" coined by Hito Steyerl. [5] Anything but material, it is infinitely replicable, shareable, and compressible.

Let us now distinguish analog and digital as two different electronic impulses. They share the same ontological basis but differ in their historical association and aesthetic. There is a similarity in affect and intensity, but the emotional subjective content diverges. Flickering between digital and analog impulses, we find tension in the continuity of affect and discontinuity of emotional association. The tension and anticipation between analog and digital impulses opens up the additive space of movement and potential.

Paul Vester's 'Picnic' (1987), a music clip made for the 'Residents', demonstrates the use of movement and potential in action. Vester uses a multiplanar, to layer digital and analog impulses. We see a superimposing of 2D animated graphic characters and lines (analog) onto live-action architectural shots (digital). Digital and analog are enacted on the same image, yet they seem strangely distant, not merging seamlessly together. Photographs and Illustrated figures enter a dialogue but are still ultimately meant to be read as themselves. This discontinuity between the two signals translates to Vester's messages of urban anxiety and the faceless

3 Massumi, Parables for the Virtual.
4 Maughan-Carr, "The Ecology of Grain."
5 Hito, "In Defense of the Poor Image - Journal #10
6 Image from "Picnic.Jpeg." November 2009 - e-Flux."

workers that occupy American urban spaces. The layered graphic figures also operate at separate frame rates than the photographed backgrounds. The various time structures inherent to the work create disunity, both in terms of the imagined space within the work and to any sense of linear time. Movement and potential are used to both illicit emotional tension and demonstrate narrative points.

Pushing the idea of flickering between digital and analog impulses I experimented with a technique of 'filmless' 16mm animation. A process gleaned from the coding tutorials at sixteenmillimeters.com. The process is called 'filmless' because it creates 16mm strips not from gelatinous film, but from any available material. This is great for costs, accessibility, and unexpected textural results. Albeit, specialized printers and laser cutters are needed.

I chose an area close to Canary Wharf for the thematic relevance: the urban anxiety evident in its erasure of Historical spaces, the 'uncanny' unhomeliness of the aesthetic and the pervasive dislocation of time. I animated a disembodied movement through space, along which, digital and analog versions flicker from one to the next. Below are examples of the analog and digital variations of the same frame.

Stills from 'God Luck Hope' animation. In order: 3D digital impulse. 16mm projection analog impulse. Distressed 16mm scan analog impulse.

An Attempt to Pollinate Movement and Potential into the "filmless" animation workflow

Step 1: Create your digital mise-en-scène
The starting point was extracting the 3D geometry of the city using satellite data from Google Maps. With the 3D city intact (albeit, intentionally deformed), the animation was rendered through a 3D animation progam (Cinema 4D) to create a digital image sequence.

Step 2: Coding and cutting
Using the code on sixteenmillimeters.com the image sequence is coded into 16mm film strip sizes and printed on to polyester film (any suitable material can be used). Finally, the print is laser cut into film strips, cleaned, and spliced together with super glue into a usable film roll.

Step 3: Distress the film strips

The film strips can be distressed or marked organically. I used several techniques. Hand sanitizer both changed color values unpredictably and had a corrosive effect. Super glue erased the image altogether. To layer foliage textures on the film, I used foraged leaves, first dipping them in black ink and subsequently pressing the leaves directly onto the 16mm film.

Step 4: Re-digitize the 16mm film

The material 16mm strips can be either scanned on a flatbed scanner or for a more vibrant result the film roll can be projected through an analog film projector. The analog output is recorded by a digital video camera. The limitation here is that the projector is designed for standard gelatinous film. Other materials can easily break. Trust me this can be frustrating as heck. The recording of the footage also offers further room for digital analog pollination.

Ultimately by layering impulses of the same image we can create a disunity and tension in the representational quality between the analog and digital. The surface becomes a site of potential where the image can cross media between digital or analog impulse. Through this interruption in-between images, a spacing in the image itself opens. The 'spaces in-between' are filled by movement and potential.

Most curiously, the recipe allows for repetition and continuous re-inputting. After all, the final digital result can always be input back into step 2. The digital and analog can fold in on each other a potentially infinite number of terms. Or at least until the white noise of compression.

Hito, Steyerl. "In Defense of the Poor Image - Journal #10 November 2009 - e-Flux." Accessed December 15, 2021. https://www.e-flux.com/journal/10/61362/in-defense-of-the-poor-image/.

Massumi, Brian. Parables for the Virtual: Movement, Affect, Sensation, 2021. https://doi.org/10.1515/9781478021971.

Maughan-Carr, Edward. "The Ecology of Grain: An Ecological Analysis of Gelatin in Photographic Film," 2019. https://doi.org/10.13140/RG.2.2.31597.41448.

"Picnic.Jpeg." Accessed June 8, 2022. https://www.cartoonbrew.com/wp-content/uploads/2015/09/0f86f82e87b93ba85502ed4ed5565365.jpg.

Sedgwick, Eve Kosofsky, Michèle Aina Barale, Jonathan Goldberg, and Michael Moon. Touching Feeling: Affect, Pedagogy, Performativity. North Carolina, UNITED STATES: Duke University Press, 2003. http://ebookcentral.proquest.com/lib/rcauk/detail.action?docID=1167951.

"Shaky Distinctions: A Dialogue on the Digital and the Analog - Journal #121 October 2021 - e-Flux." Accessed April 4, 2022. https://www.e-flux.com/journal/121/423015/shaky-distinctions-a-dialogue-on-the-digital-and-the-analog/.

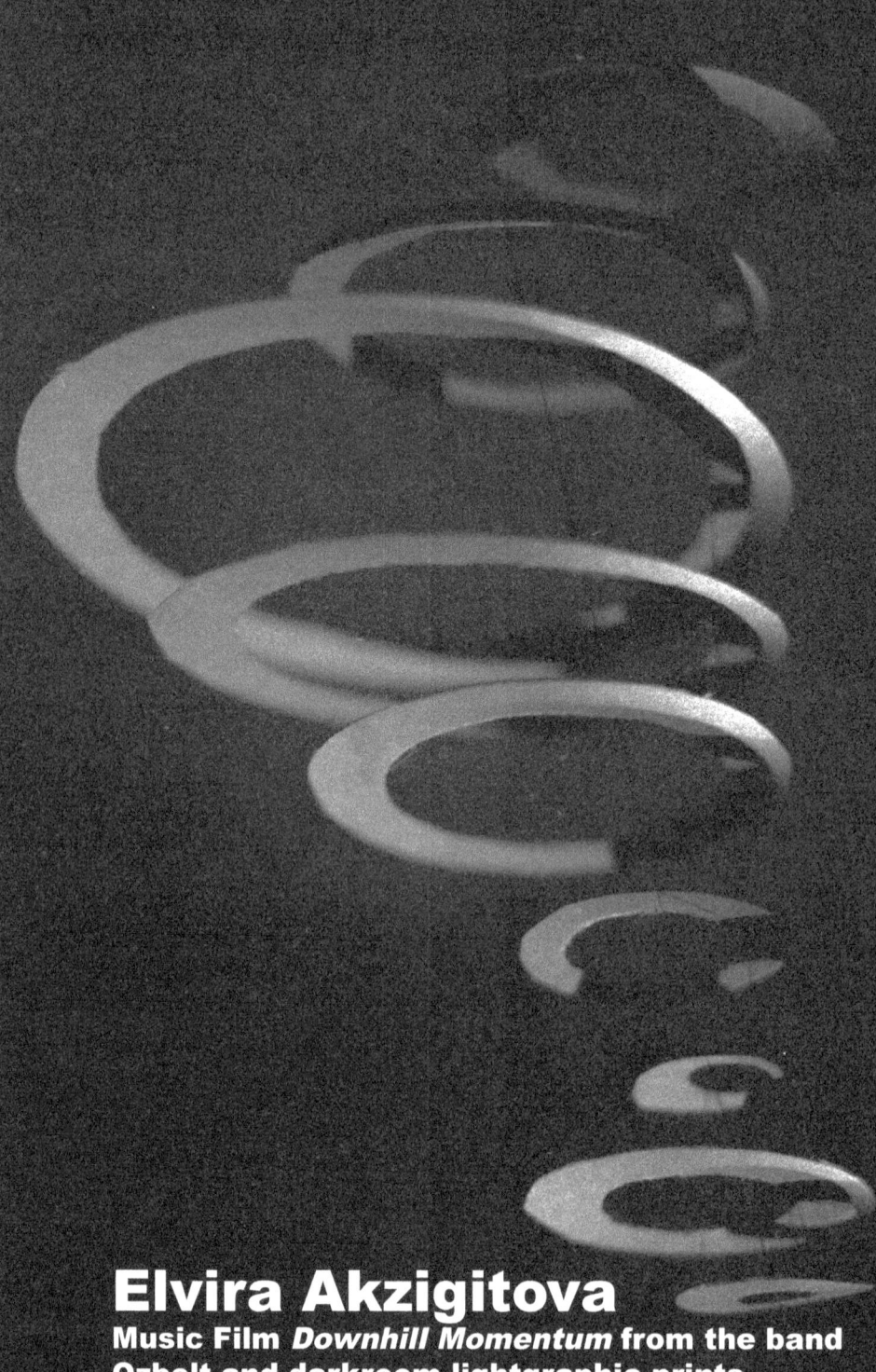

Elvira Akzigitova
Music Film *Downhill Momentum* from the band Ozbolt and darkroom lightgraphic prints.

Tell us about your background. When did you first start working with 16mm film?

For many years I have worked on creating analog optical themes in the darkroom and it had a lot to do with expressions of light and documentation of light traces. The process itself is like performance, you are in the darkness creating shadow play, molding and bending the visible. There are times when I attempt to catch a certain light quality that is a part of its transformation, but as my fellow analog experimenters already know, it is not an easy task. The desire to shoot a moving image which I could manipulate came to me during these startling late night darkroom sessions. The opportunity presented itself during my artist's residency in the fantastic film lab Filmverkstaden in Vaasa, Finland during this year, 2022.

In the music film for Downhill Momentum, you create abstract images through playing with light. Tell us about this process.

For the Downhill Momentum I have used the Bolex 16 mm camera. This was my first time alone with 16 mm film, so in Ozbolt's music video one can see the diversity of techniques I was curious to try out.
A number of shots were made straight through the shutter, lensless. I directed light through a series of objects that served as masking and various combinations of light modulators I assembled on the go. I very much work intuitively and create a setup on spot. In order for me to understand what looks good, I built a miniature theater with a white screen made of a plain paper sheet and a one end open, blackened cardboard box to avoid any disturbances and gather all my light within. I then let myself get playful and go lengths in order to catch the right position, often ending up fixing/duct-taping light sources on myself. Something alike has been practiced earlier by the artist Nathan Lerner. He developed an airtight 'lightbox' with many holes on the sides for light to enter. The artist would then fill the box with smoke, so that light traces become more evident. The spatial world would consist of a process of becoming and disappearing and I find this to be a fantastic way to experiment with light composition.

There's also a great deal of shots made with multiple exposures on all sides of the stock. As often with my darkroom practice, I had to trace my steps in a way that the interactions between the light symbols would be harmonious and dynamic. Downhill Momentum consists of fresh, expired, duplicate, positive and negative film stock. I picked up on a few ideas on how to develop the films, including solarization from your Analog Cookbook!

We also see light play in your still work on vintage expired photographic papers. These photo series are stunning. How do you source expired photo paper and what's your process with this?

Working with expired photo papers is like resurrecting the dead.
Reconsideration of the functionality and materiality of the light-sensitive material often rewards me with more nuance after development. It seems to be their silver content, and at times, paper storage can

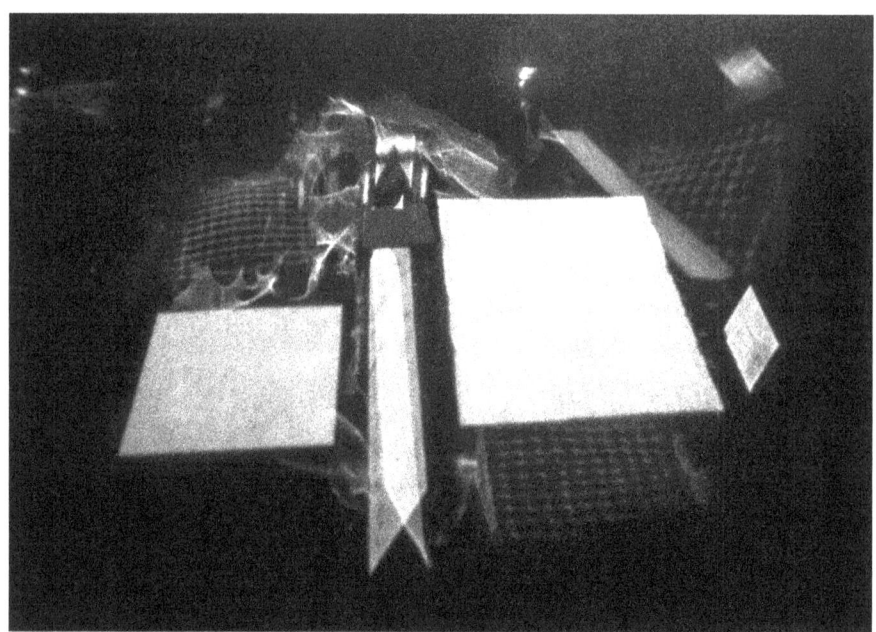

surprise me with a light leak or a whole new texture from being exposed to light by the previous owner. Working analog has a sort of advantage because 'retired' artists like to support ateliers or individuals by giving away their old materials. Obviously, if one exclusively depends on these donations, it can make work inconsistent. But as long as there are leftover East bloc rolls in dusty basements, I want to get my hands on them! It's not only a benefit to my process but I also see it as a kind of recycling and going against the idea that to be a great photographer/printmaker you need to play it safe. The darkroom forces me to step out of my familiar mode of performance. Here the blank light-sensitive material interacts with light, my body and everything else involving time and movement. I navigate this space with a mix of playfulness, experimentation and technical knowledge.

Who are some of your inspirations?

The life-long work of Werner Herzog moves me. I still daydream of being part of his film crew and going on an expedition. He and a handful of other visionaries represent the masters who still carry the flame within, meaning the willingness to go all the way into the unknown.

In my work one can see the excitement and freshness of the earliest Dadaist film mutators, including the Berlin based Heinz Hajek Halke, who coined the term I also use for my works, "Lichtgrafik". However, my photographs resonate as a timeless collaborator with this generation, rather than a linage. Books that stimulated me on the topic of seeing are 'In Praise of Shadows' by Junichiro Tanizaki, 'Language of Vision' by Gyorgy Kepes, and 'Vision in Motion' by Laszlo Moholy-Nagy.

What's your favorite go-to camera, film stock, or tool?

I embrace whatever material comes into my hands. Each vintage film and paper have taught me ways to see, develop and print through unforeseen means. Light sensitive materials from Soviet and GDR times make me feel like a scientist or magician in the film lab. To keep myself stimulated and let my mind travel, I only use familiar stock when I've got a fixed task like a final artist print or commission work. But even then, people often trust the spirit of experimentation and gladly join me in my venture.

Curious to use darkroom instruments that are sensitive enough to detect what one cannot see with the naked eye, I acquired an electric device from the 20's. The Violet Ray (or Violet Wand/High Frequency Device) played a huge role in my early photographic explorations.

You also do workshops on cameraless light design. What do you hope your students walk away with?

Someone once referred to the history of photographic practices as an unattended garden.
Darkroom work is mostly solitary work, and when successful, the process is led by discovery and deep feeling. I want to charge my students with the enthusiasm of experiencing the full potential of working in the darkroom and guide them through the process. A big part of my workshop is breaking their own hardwiring of photographic knowledge, with my personal mantra of experimentation, chance and artistic self nourishment. It requires courage to look inward and I see it as a philosophical, often a poetic process. Since 2018, I have witnessed incredible original work being made during this workshop. Together with the participants we strive to achieve something of significance and ingenuity to broaden our horizon of photographic vision.

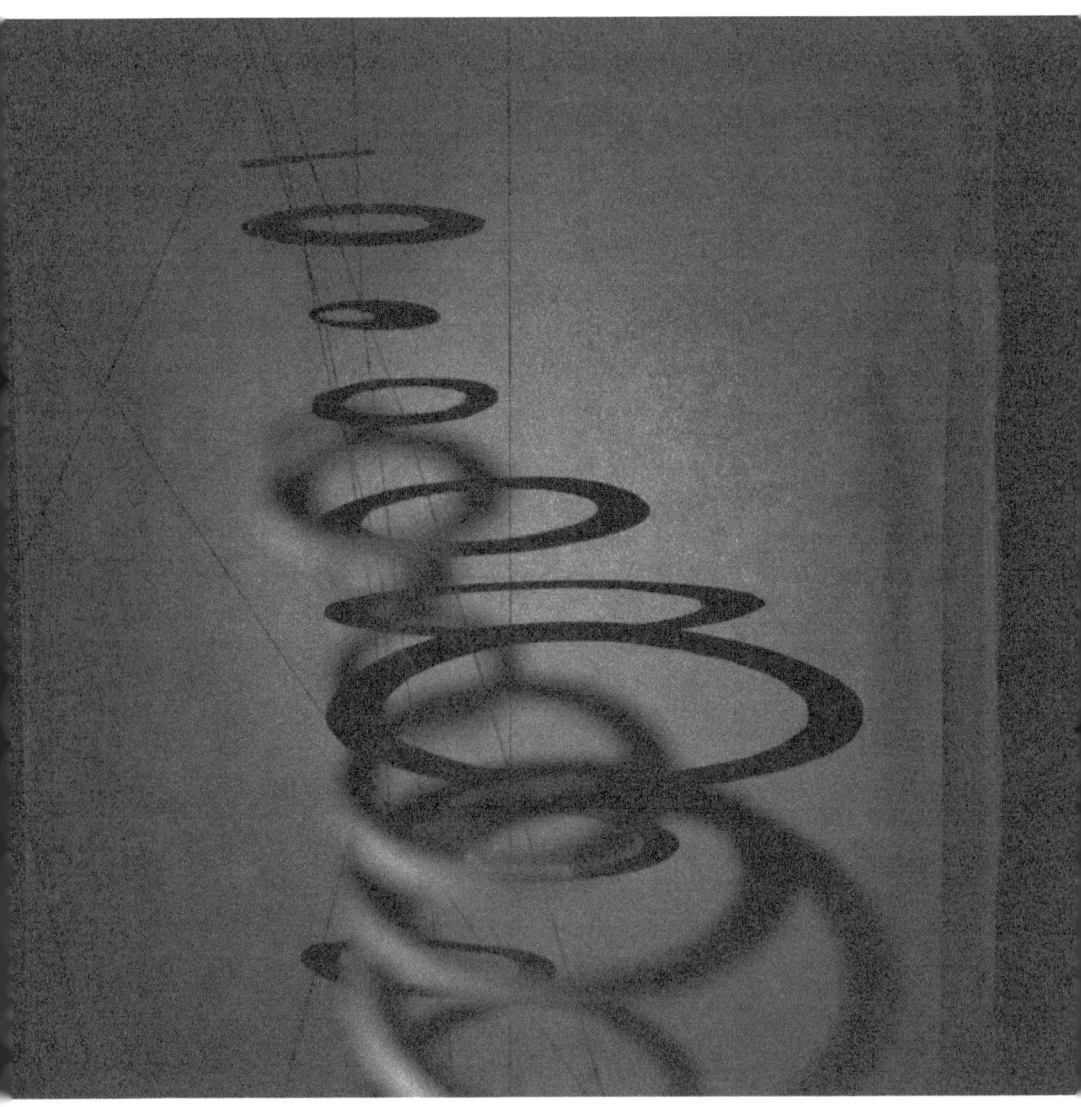

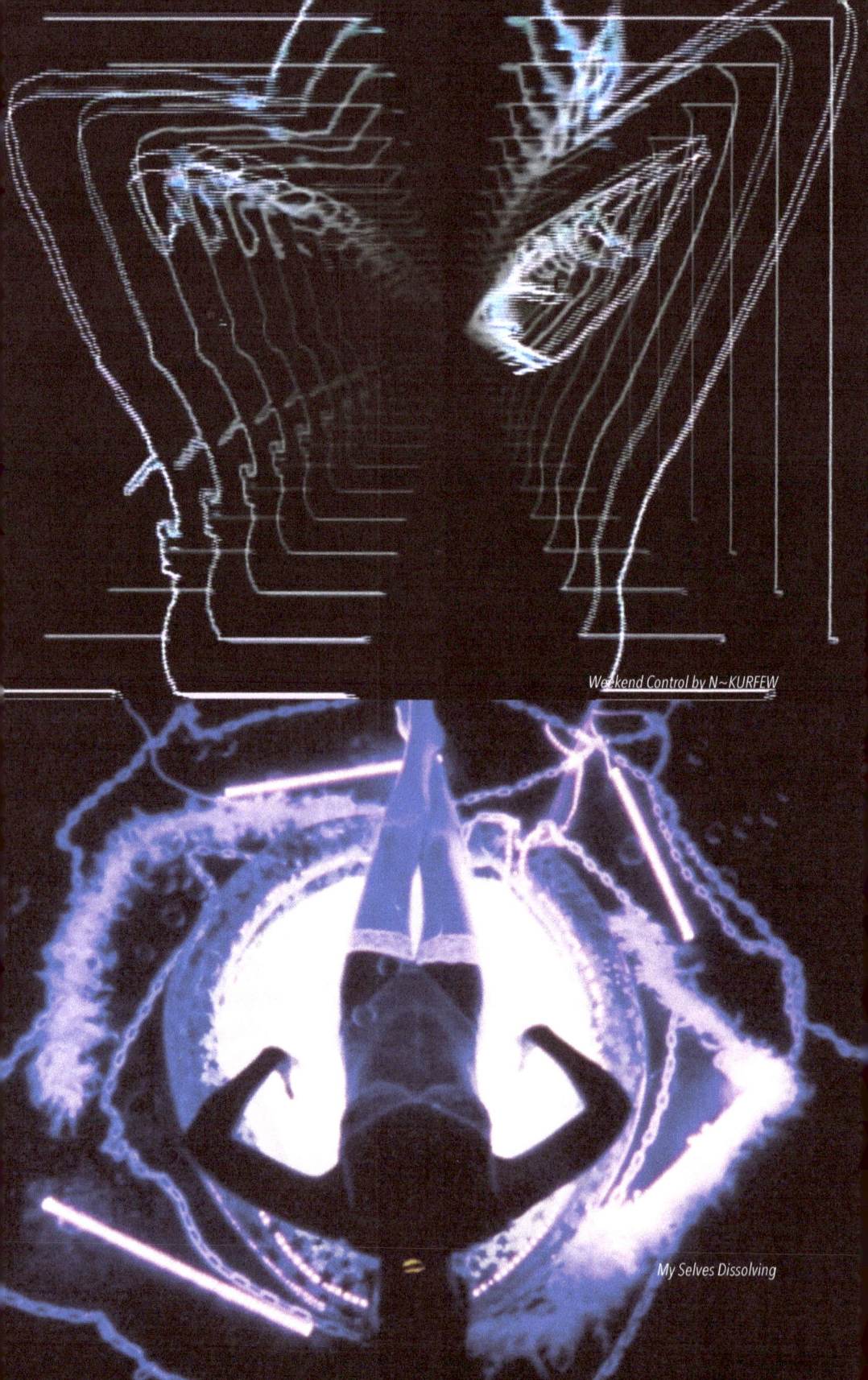

Weekend Control By N~KURFEW & My Selves Dissolving: VHS and 16mm films by Danielle Wakin

About *My Selves Dissolving*: *My Selves Dissolving* travels through the sensations during out-of-body experiences. Themes of dissociation are explored such as sleep paralysis, autoscopy, and ecstatic moments. The abstracted images are visual adaptations of these experiences. Exploring the unexplainable.

Tell us about yourself. When did you first start working with film?

I have been creating film and video work for about ten years. Film was a natural progression from my love for analog photography. I first started working with film my last year of undergraduate. I took a moving image class and when I saw the first 200ft I shot projected that was it; I was fully entranced. I basically switched my major and took as many experimental film classes as possible. I ended up spending all my time in the optical printing room and eventually purchased a Bolex off another student. I haven't stopped working with film since and that passion remains. I also work as a 35mm projectionist, so celluloid is my world!

Why was it important to show themes of out of body experiences in My Self Dissolving on film?

My Selves Dissolving was a deep dive into my own out of body experiences. I have always had very intense sleep paralysis. Which is when your mind is "awake" but your body is paralyzed. During this state you can have hypnagogic hallucinations and these can be visual, auditory, or sensory. These hallucinations started to inspire my abstract work. I started to jot down these hallucinations in a notebook and recreate scenes with actors. It started with abstract experiments and grew from there. I also think that watching a film can be an out of body experience. Unlike a near death experience, this is something people willingly do in a dark room together. When watching a film we disconnect from our own body and fully immerse ourselves in this trance state. This stimulation takes us into the screen, getting wrapped up in the world created. I think it's a specific craving to feel outside oneself.

This film has such unique visuals. How did you go about creating these abstract brightly colored images using 16mm film?

I use a lot of different DIY lighting in this film. I used a lot of gels over a hot light, black lights, lasers, and LED tube lights. I am all about practicality and keeping it low budget. I did cheat a bit and used some analog video equipment. My second love is video synthesis, which I am guilty of transferring back to film. It makes for some unique textures/ color palettes.

Tell us about the title work in My Self Dissolving.

The title work in the film was made using

video feedback from an LZX module. I then recaptured it on an Arri SR2 200D stock from a flat screen TV. This method worked in favor of allowing the letters to drip and dissolve.

How did you create the soundscape for My Selves Dissolving?

The soundscape was a collaboration with my partner and electronic musician Brian Porter. He created a multi-layered electronic score. I am grateful for how intuitive his work flow was. When I felt stuck he was able to read my mind and send me a section that was exactly what I wanted but didn't have words for. We used many field/voice recordings and he processed them using Ableton. The process was very trial and error. I would show him dailies and give him field/voice recordings to use for the scenes. We ended up breaking up everything in chapters, tackling each section at a time. 16mm optical tracks can be challenging to mix, we lost a lot of the low end but I prefer the warmth it has.

You also created the visuals for the song Weekend Control by N~Kurfew. Tell us about this collaboration and your process for creating these visuals.

Working with Nate was a very relaxed process. He saw some of my work on instagram and asked me to make a video for the song. He has been collaborating with different film/video artists to make videos for each track of his upcoming album. I ended up making the piece during a long jam session using an old VHS porn tape. I recorded it in real time and later cut it together. For these videos I mainly used a downstream keyer on an old broadcast television video mixer. I also incorporated some analog circuit-bent gear built by Tachyons+. Nate gave me total freedom and trusted me to make the video without any guidelines. This was one of my favorite commission pieces to make because I had full creative control.

Which do you prefer VHS or 16mm more? Or do you take a hybrid approach?

I take a more hybrid approach for sure. As mentioned I really enjoy mixing both processes. I need this improvisational approach to image making. Like film, you won't always get the same image twice with analog modules. You can write notes, take pictures of patches, etc. but like re-shooting a scene on film it's always going to be inevitably different from the original. Chance based experimentation is at the core of how I keep myself inspired and both lend me this. My first love is film though, if I could afford it I would shoot everything on film.

What artists or films inspire you?

Some artists that inspire me are Hilma Af Klint, Pipilotti Rist, and Betzy Bromberg. I am of course inspired by my friends' art - be it music, costume design, films, photography, etc. Same goes for my students, when I have the opportunity to teach, I always get so excited for their screenings!

What's next for you?

I am currently working on writing my first experimental narrative feature. It is definitely something new for me and writing a formal script has been inspiring in itself. Very fresh so don't want to say too much! Also, my friend and amazing artist Leanna Kaiser and I run a DIY screening of local artists called Silver Dusk in Echo Park. We are currently in the work of expanding from a backyard screening into a larger venue. I am also working on music videos for musicians, which is always inspiring. Other than that just focusing on experimenting in my studio while finishing this new script.

Anything else to add?

I am always open to commissions, collaborations, and I also sell my video stills on https://www.inprnt.com/gallery/chromeblood/ if interested :)

Rainbow Tunnel Films

Artist-run full service creative studio specializing in independent film and photography projects - with a shared love of analog practices, alternative processing, and 70's country music.

Tell us about Rainbow Tunnel Films! When did you two decide to create a creative studio specializing in film and photography?

Rainbow Tunnel is the joint venture of Sarah Phenix and Claire Donohue. We were living together in Santa Cruz when we dreamed it all up. We had both been working independently and saw a big overlap and admiration of each other's pieces. I think we just wanted a space to collaborate, critique, and feel a little more confident reaching out to friends and potential clients. Giving it a name and website was really just the push we needed to share the work we made collectively and try and feel a sense of community outside of our day jobs and academia. The name comes from the rainbow painted tunnel that separates San Francisco from Marin County (where Claire grew up).

Sarah, tell us about your background as a filmmaker.

I loved to make my own montage films and sourced archival footage when I was younger, but I considered myself a photographer in the beginning of my art practice. When I moved to San Francisco in 2018 I started working in a 16mm archive called Other Cinema under the mentorship of Craig Baldwin. I learned so much there and it ignited a passion for analog filmmaking, specifically with 16mm experimentation. Then when I started collaborating with Claire, her critiques, editing lessons and sharing of knowledge really helped solidify the practice for me! We've been filming nonstop ever since. I have a personal art practice as well as work with Rainbow Tunnel and view these as constantly fueling each other, my approach has always been multidisciplinary and experimental.

Claire, your film *Side Effects May Include* was featured in previous issue of Analog Cookbook. What have you been up to since?

It was such an honor to share that piece via Analog Cookbook! I still work full time as an editor for my day job and have been putting a lot of love and labor into Rainbow Tunnel on the side. It's been so incredible to have someone to bounce ideas back and forth with. Sarah's taught me so much about her preferred mediums and I've been branching out into 16mm and some more 35mm photography work.

What's been the biggest obstacle starting a creative studio specializing in film?

Maybe it's an overstated answer but the cost and lack of access to film really is our biggest block. It's hard to feel confident about giving clients reasonable day rates when you're also charging them $100+ for each 50ft roll you shoot. I think we often sacrifice our own time to make up for the extra fees. Musicians' release dates shift constantly and having to incorporate sending our rolls down to LA for processing is also a challenge to explain.

You have quite a few music films (music videos shot on film). What's your process like working with musicians to create these films?

It varies so much project to project but typically we request the songs and lyrics and then set up an initial meeting with the band a week or so later. We bring a few

ideas and reference videos to the table and listen to their initial thoughts and timeline for the piece. We'll work collaboratively on mood boards and scout some locations. Some videos are pretty loose (we'll pick a spot and see what happens) and some require a bit more storyboarding and direction. We always love hearing what a song means to an artist so we can create something that feels true to that original vision.

Who's your dream client?

We've been dreaming of working with Swanton Berry Farms in Davenport, CA since we started. It's one of our favorite places to visit and it has an incredible history as the first organic farm in America to sign a contract with the United Farm Workers. The landscape is stunning and it has such a special place in our hearts - telling their story on film would be incredible.

What's a favorite go-to analog filmmaking tool that use?

Claire just bought a Krasnogorsk-3 that she's so excited to work with but her trusty Canon af 310 Super 8 has been her all-time favorite tool for the past few years. Sarah's favorite tools are her Bolex 16mm Camera, her Braun Nizo Super 8 Camera and her Rolleiflex Medium Format Camera!

Favorite film stock?

I think we can both confidently say Kodak Ektachrome 100D. It's what we use for many of our music videos and the hues always exceed our expectations.

What do you hope for the future of Rainbow Tunnel Films?

We're trying to get into the routine of applying for grants and funding. We're completely self started/funded and think it's time to start branching out. Expanding the team in the future and working with other local DP's, producers, writers, musicians, and directors would be incredible. We just had our first Rainbow Tunnel mixer night in Oakland and can't wait to throw more screenings and parties to connect with the community in the Bay Area.

Any projects you're working on currently that you share?

We just shot a music video this past week for an artist and friend named Bella Porter that we can't wait to release! It was our largest production to date and included a cast of 10 young kids having cannonball contests and water balloon fights. Directing kids was a new process for both of us but was so rewarding. They're such blank slates and do such unexpected and exciting things when given the freedom to improvise. Bella's music is also so tender that the medium and cast felt perfect.

Anything else to add?

We want to put the call out to Bay Area based analog filmmakers! We really started this because we weren't finding this community at our jobs or schools and just wanted to gush about film and get inspired. We're on instagram @rainbowtunnel and on the web at rainbowtunnel.co and plan to have more screening nights and workshops in the coming months.

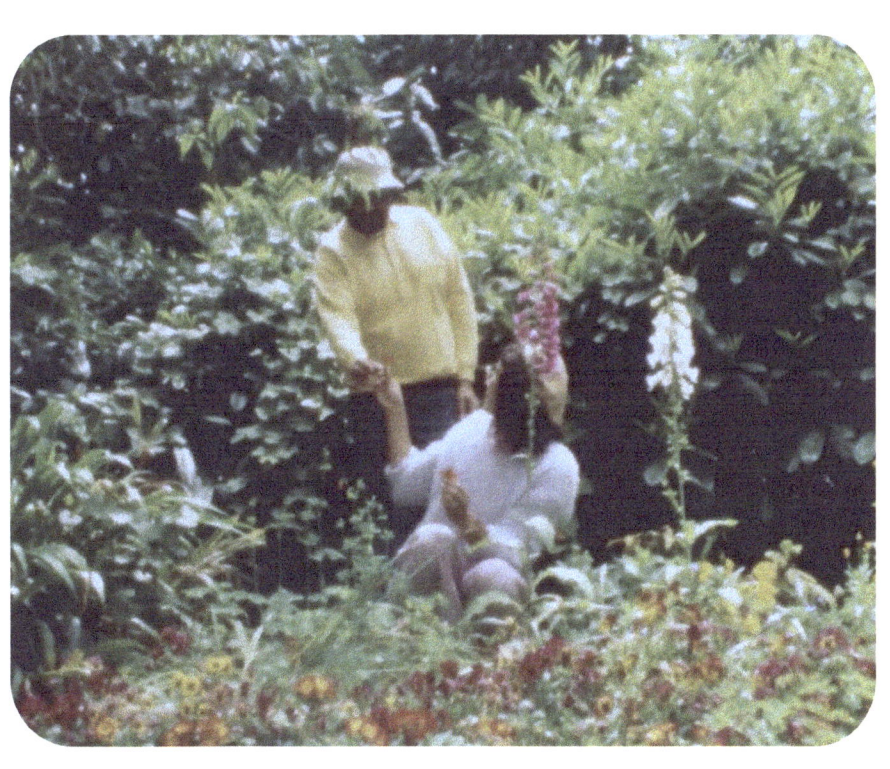